CENTRAL NEW YORK
&
THE FINGER LAKES

MYTHS, LEGENDS

CENTRAL NEW YORK
&
THE FINGER LAKES

LORE

MELANIE ZIMMER

Charleston London

THE
History
PRESS

Published by The History Press
Charleston, SC 29403
www.historypress.net

Cover design by Marshall Hudson.
Cover image: Railroad Scene, Little Falls. Steel engraving by R. Sands after drawing by
W.H. Bartlett. *Courtesy of the Library of Congress and Photographs Division.*

First published 2008

Manufactured in the United States

ISBN 978.1.59629.464.6

Library of Congress Cataloging-in-Publication Data

Zimmer, Melanie.
 Central New York and the Finger Lakes : myths, legends, and lore / Melanie
Zimmer.
 p. cm.
 Includes bibliographical references.
 ISBN 978-1-59629-464-6
 1. Finger Lakes Region (N.Y.)--History--Anecdotes. 2. New York (State)--History-
-Anecdotes. 3. Finger Lakes Region (N.Y.)--Biography--Anecdotes. 4. New York
(State)--Biography--Anecdotes. 5. Folklore--New York (State)--Finger Lakes Region.
6. Folklore--New York (State) 7. Legends--New York (State)--Finger Lakes Region.
8. Legends--New York (State) I. Title.
 F127.F4Z56 2008
 974.7'8--dc22
 2008029067

Notice: The information in this book is true and complete to the best of our
knowledge. It is offered without guarantee on the part of the author or The History
Press. The author and The History Press disclaim all liability in connection with the
use of this book.

I dedicate this book to the memory of Pat Dixon, who was librarian for many years at the Vernon Public Library. Pat died suddenly a few weeks before this book was due to the publisher, surprising everyone. Recently we had talked about Route 5, known locally as the Seneca Turnpike, which served as the gateway to the West. She spoke of the many people who traveled through this small village in their westward journeys. Pat's family has lived in this area for some time, and she told me how one of her ancestors had been tomahawked.

Pat worked at the Vernon Public Library, a building which was the historic stable of Dr. Lewis. Pat didn't simply work at the Vernon Public Library. I firmly believe she was the very heart of the library. Pat was intelligent, vibrant, sensitive and interesting. She was a beautiful person, and will be sorely missed. Pat Dixon died on May 12, 2008.

Contents

Acknowledgements 9
Introduction 11

PART I: IROQUOIS STORIES
The Creation Story 15
The Giant Bear and the Big Dipper 18
The Formation of the Finger Lakes 19
The Story of the Standing Stone 20
Hiawatha and the Peacemaker 23
Blessed Kateri Tekakwitha 27
The Martyrdom of Three Jesuits 33
The Strange Story of Eleazer Williams, the Dauphin of France 39
Buffalo Bill's Wild West Show and the Oneida Indians 49

PART II: THE REVOLUTIONARY WAR PERIOD
Chief Skenandoah 53
Polly Cooper at Valley Forge 59
A Transatlantic Love Story 59

PART III: THE ERIE CANAL
Stories of Red McCarthy 67
The Empeyville Frog 70
Snow Dye 73
The Dry Canal 73

CONTENTS

Sig Sautelle, the Circus Man 74
A Whale of a Tale 81

PART IV: RELIGIOUS MOVEMENTS AND UTOPIA
A Miracle in Palmyra 87
The Oneida Community 102

**PART V: ABOLITIONISTS, UNDERGROUND RAILROAD CONDUCTORS
 AND SUFFRAGISTS**
The Scythe Tree 107
The Jerry Rescue 109
Harriet Tubman 112
Gerrit Smith 116
Elizabeth Smith Miller and the Story of Her Bloomers 119
Elizabeth Cady Stanton's Bible 121

**PART VI: LEPRECHAUNS, BASEBALL, THE CHOCOLATE TRAIN
 AND A STONE GIANT**
Thomas Hastings's Heavenly Music 127
The Cardiff Giant 128
Baseball, the All-American Sport 133
The Great Chocolate Wreck 135
The Origin of the Spotted Cow 136
Cat Tales 136
Small Wonder 137
George "Bill" Bailey, the American Mummy 138
The Guardian Angel 140

Conclusion 149
Selected Bibliography 151
About the Author 155

Acknowledgements

There are numerous people who gave assistance to this project, and to each of them, I would like to offer my sincere thanks:

Kaarin Gerlock of the Waterloo History Project offered information on the Scythe Tree, brought me to see it and gave me information on the strange case of George "Bill" Bailey. She was trusting enough to allow me to borrow historical records for a time so I could create a scan of an image of George "Bill" Bailey. Doris Wolf was very helpful to me regarding "Bill" Bailey and other stories. Joseph Siccardi, owner of the *Reveille*, allowed me to use an image of the embalmed George Bailey. The Terwilliger Museum gave me assistance on "Bill" Bailey. Francis Caraccilo told me the whale story and the tale of "Bill" Bailey's toe. The Seneca Falls Historical Society allowed the use of a historic whale poster image. Tom Heitz was very forthcoming with information about the Cardiff Giant, and baseball's origins. He sent me a photograph of the giant and a song he had written about it. Pat Dixon offered help on matters of local interest. The Cortland County Historical Society allowed me to use information on Sig Sautelle and a few historical photographs of the same. Dr. Anthony Wonderley, curator of the Oneida Community Mansion House, offered some stories of strange occurrences and helped me obtain a historic photograph of the Mansion House. Kate Moss, former curator of the Mansion House, talked to me about Oneida Community lore. Fred Fazekas, known locally for his stories, told me about the giants at the Oneida Community. Ronald J. Deeley added to the long tradition of Empeyville Frog lore. Joe Robertaccio was very helpful regarding the Revolutionary War period. Betsy Mack, historian for the town of Trenton, was helpful regarding research on *The Guardian Angel*. Ray Ramsey allowed

me to use his extraordinary research regarding *The Guardian Angel*, sending me countless nuggets of information via FedEx. He also went out of his way to photograph the magnificent *Guardian Angel* painting. Nadine Thomas was such a dream, digging deep into the past at the Unitarian Church in Barneveld to satisfy my historical curiosity about *The Guardian Angel*. Kandice Watson, Cultural and Educational Outreach Director at the Oneida Indian Nation Shako:wi Cultural Center, granted me a personal interview about the story of the Standing Stone through Mark Emery at the Oneida Nation. Some information on Eleazer Williams's Indian church was obtained from Ellen Murphy, president of the Vernon Historical Society and historian for Vernon, who was kind enough to supply a picture of the Indian church.

I would like to extend special thanks to Dr. Daniel Ward, Regional Folklorist for Central New York at the Cultural Resource Council in Syracuse, for all his kind help and direction. Dan introduced me to a number of marvelous stories and put me in touch with numerous contacts. He is a great storehouse of information.

I would like to thank the librarians at the Burke Library at Hamilton College, where I have spent much time laboring. Hamilton College houses some unique collections, I believe in large part due to its past as the old Hamilton Oneida Academy. I am fortunate to live so close to such an extensive collection of works.

I would like to thank The History Press for inviting me to write this book. They sought storytellers as authors, hoping they would have inside information on regional legend and lore and a way with words. I hope I haven't disappointed them. Thank you for finding me and believing in me. I would like to give a special thanks to Melissa Schwefel, my first editor who was of great assistance before she left; Magan Lyons, who helped during the transition; John Wilkinson, my current and agreeable editor; Ryan Finn, who made corrections to the manuscript; and the other fine people at The History Press.

Of course I would like to thank my husband, who has given me moral support, scanned photographs and read my manuscript. I do hope I have forgotten no one, but the list is long, and it could be so.

And finally, thank you for purchasing this work. Enjoy!

Introduction

Here in the very middle of Central New York, I live in a small village of perhaps eight hundred people. The actual center of the state is approximately four miles west of here in Oneida Castle, which was considered a possible location for the capital of the state of New York. The land is subject to the whims of nature; it is brilliantly green during the summer—as if someone had accidentally painted it with unrealistic intensity—and, some say, white during the rest of the year. Kaarin Gerlock of Waterloo recently commented to me that if a man were walking home from the Civil War today, he would still be able to find his way home. The slow pace of change helps keep us strongly tied to our past, and the abundant myths, legends and lore of these regions remain alive and flourishing.

This is the place where I became a storyteller. Back then, I was taken by European folklore, the kind of fare we all grew up hearing. I remember wondering if we were just too young a nation to have our own folk tales, as folk tales seem to develop and change over numerous generations. As time went on, I learned differently. I found a wealth of myth, legend and lore awaiting me right here in my own backyard.

I have tried to create what is a coherent "history" on these pages—not just a few stories stuck haphazardly together, but rather a legendary history that is for the most part linear in time, starting at the earliest known point and progressing to present day. Whether or not a story happens to be embellished over time, or even if it, in the end, is something that may never have actually happened in the physical world, it is the truth behind it that we really have to see. In that sense, this work is far more than a collection of stories. It is the truth of our history and of this place.

INTRODUCTION

I wish I had more time to write this book, and more pages allotted to it, as the region's lore is so abundant, it simply cannot be contained within the confines of this book. I can offer you only a taste of the richness of the region. In a sense, though, that is good, for when you have completed this book, you will realize it is not an end to the stories but only a beginning.

Part I

IROQUOIS STORIES

L ong before settlers from Europe arrived in North America, the Iroquois lived in the area we now call New York State. Every land has its beginning, and this is the way the Iroquois remember theirs.

THE CREATION STORY

Once, long ago, there was no land, only an immense sea. It was a giant sea devoid of light or land. Humanity dwelt in the regions of the sky, and everything was in abundance. The forests overflowed with game, and days were filled with resplendent sunshine. Storm, scarcity, death and pain were not known, and the people lived lives free of jealously, hatred and malice.

With time, however, one man began to withdraw into himself. The others wondered what troubled him, and at last he told them that he would reveal this to them if only they would dig up the roots of a certain great white pine tree and place him by the side of the hole with his wife. The people soon completed this task when, to their horror, he threw his pregnant wife down the hole into the darkness. The man then rose and told the others that for some time he had suspected his wife's chastity, but now since she was gone, he felt completely healed in mind and body.

Various aquatic animals dwelled in the aqueous world below, and the loon was the first to observe the woman falling toward them. The animals called a council to decide what they should do. They understood that the Sky Woman would need earth beneath her so that she would have a place to stand. The sea bear volunteered to support her, and the others scrambled on his back to test his strength, but he soon sunk beneath their weight. Several

other animals tried, but with similar results. At last the turtle volunteered, and all were unable to sink the modest turtle, and so turtle received the honor of supporting the world.

Next the animals discussed how they might obtain soil and soon concluded that it might be found at the bottom of the sea. Mink volunteered to obtain it, but try as he might, he soon floated up dead to the surface, so deep below was the soil. However, when the animals examined him, they found a bit of soil clutched in his paw. This was placed on the back of turtle. When Sky Woman landed, there was only enough soil to stand on with one foot, but soon it grew so she could stand with both feet down. Then she could be seated, and the soil continued to spread until at last all the great turtle's back was covered. The land became a small island, and then a great plain was added and then streams and shrubbery.

Soon the woman moved to the shore and built a hut there. She gave birth to a baby girl, and the earth supported the girl until she became a woman. When it was time for this young woman to wed, several of the sea animals took on the forms of young men and presented themselves to her. The loon became a handsome young man, but was rejected, as were several others until the bandy legged turtle presented himself and was accepted as her suitor.

When the young woman laid herself down to sleep, the turtle placed two arrows on her stomach in the shape of a cross. One was a flint-headed arrow, and the other was fashioned of rough bark. Then the turtle left, and in time the woman gave birth to two sons, but she died during childbirth. The younger son was born in the normal way, but the older son, filled with aggression, burst through his mother's abdomen, destroying her. This was taken as the first sign of the older son's nature.

The grandmother was enraged at the death of her daughter, and led the sons to the sea to leave them to be destroyed. Though she tried several times, each time the boys beat her back to the hut. At last, discouraged, she decided to allow the boys to live. She divided her daughter's corpse in two and threw the halves toward the heavens. The upper half became the sun and the lower the moon. This is how day and night began.

The boys soon became men, and expert archers. The eldest son was named Flint and he had the arrowhead from the turtle pointed with flint. The younger son was kind and benevolent. His name was Shukwayátisu and had the bark-headed arrow.

Flint, due to his malignant nature, was an expert hunter, and despite the abundance of food he obtained, he refused to share any with his brother, who could kill only birds with his bark-headed arrow.

One day, Shukwayátisu was by the sea. He saw a bird carrying a bough over the water. He shot at it, but his arrow missed and fell into the sea. The young man was determined to retrieve it and followed it beneath the waves. To his astonishment, he found a cottage there.

An old man was seated in the cottage, and welcomed the boy:

> *Welcome, my son, to the home of your father. I have directed these circumstances to bring you here to me. Here is your arrow, and here is an ear of corn that you will find to be pleasant and wholesome. Your grandmother and brother have been unkind. Wherever your brother dwells, the earth will never be peopled. You must, then, end his life. When you return, walk the face of the earth and collect all the flint and throw them into heaps. Then take all the buck horns and hang them up. These are the only two things your brother is afraid of, and can injure him. You will always have weapons at hand against him then.*

After the turtle told these things and others to his son, the young man returned home and followed the instructions. Soon Flint decided to go hunting. He asked his younger brother what most terrified him, and the young man told him, falsely, that it was beech boughs and bulrushes. The younger son asked Flint what he was afraid of, and Flint told him only buck horns and flint could affect him. At last, Flint went hunting and the younger son set about building his hut and preparing the accommodations.

Finally, Flint returned hungry and tired. His brother prepared him a meal and then Flint retired into his hut to sleep. When Flint was sleeping deeply, his brother kindled a fire at the entrance to the hut. This caused Flint great discomfort as the flint materials of which he was composed began to expand as he heated up. Large scales began to break free from his body. He, at last, broke through the fire and sought revenge upon his brother, beating him with beech boughs and bulrushes, but to no avail. The younger brother pelted Flint with buck horns and flint until Flint ran off. He returned again to fight, with the same result, and at last he fled as the earth trembled.

Before Flint lay a rich green plain of fertile land, after him lay precipitous mountains and frightening chasms. Where streams flowed quietly before, they now rushed down the mountainsides, forming cataracts across the rocky terrain to the sea. The younger brother followed Flint, continually wounding him with buck horn and flint until the older brother finally breathed his last. This, the dying place of Flint, is thought to be the Rocky Mountains.

With the great enemy destroyed, the turtles came up out of the ground in human form and multiplied in peace, spreading across the land. The

grandmother was filled with rage at the death of her favorite, and to avenge him sent torrents of rain upon the land until the whole surface of the earth was covered. The inhabitants boarded their canoes and paddled away to avoid destruction.

Next, the grandmother made the rain cease and the water subside, and the turtle people returned to their homes. Then she sent a deluge of snow to torment the people, hoping to destroy them all, but the people made snowshoes and fled the disaster. At last, the grandmother accepted that she could not destroy the whole race at once, but determined that, instead, she would inflict all manner of hardship on humans. Shukwayátisu, on the other hand, blesses the world with great goodness.

This story is based on the version recorded by early settler James Dean, who served at one time as an interpreter to the Oneida Indians. Traditionally, the Iroquois had no written language and so this very early version was recorded by a settler and not an Iroquois. I chose this version to tell because at the early date when this was recorded, there may have been less contact with Christian settlers. Some versions feature different animals in the tasks of creating a place for Sky Woman to stand. In some versions, Flint is not killed, but rather exiled between earth and Sky World. Additional variations of the story may include differing reasons for Sky Woman's fall to earth and what she carries with her.

I asked Kandice Watson, Cultural and Educational Outreach Director at the Shako:wi Cultural Center of the Oneida Nation, if she was aware of any spot where the first turtle people came to earth. She suggested that there might be a spring located on a private farm between Oneida and Onondaga lands that is venerated. The Canadian Oneidas come to that place yearly to hold a ceremony.

THE GIANT BEAR AND THE BIG DIPPER

Stories among the Iroquois are traditionally told in the winter, after the first frost and before the last snowflakes fall to the ground. That is because if these stories were told in the warmer times, birds and other animals might stop to listen, when they really should be doing other tasks such as building their nests.

Long, long ago, there was a Mohawk village along the Oswego River. One day, hunters discovered giant bear tracks in the snow. Soon, it became common to see the tracks of the giant bear, and sometimes, ominously, they circled the Mohawk village.

It was not long before the bear began killing many of the animals in the forest to feed himself, leaving little left for the people of the village, and they began to know hunger.

The people decided to send a party of warriors to hunt the bear. They left forthwith, and followed the bear's giant tracks for days until they found him. The warriors filled the air with arrows, but they had no effect on the mighty bear. The bear attacked, killing all the hunters except two, who returned to the village with the news. Many parties of warriors were sent to kill the bear, but each one failed and the people wanted for food all the more. They feared that the bear would circle their village, and the people huddled together by the fire at night for both protection and warmth. The people became afraid to leave the boundaries of their village, for they could hear the growls of the gigantic beast not far away in the forest.

Three brothers had a dream that they would kill the mighty bear. Each night for three nights, they dreamed it, and they realized this was a special vision and must be true, so they armed themselves and pursued the bear.

They followed the bear tracks for months until they came to the end of the world, and they saw the giant bear leap into the sky. The pursuers did not hesitate to follow him. Even now, you can see the three brothers chasing the bear across the sky in the form of the Big Dipper. The four stars of the dipper are the form of the bear, and the three stars of the handle are the hunters.

When autumn comes, the bear prepares for hibernation, and the hunters draw near and shoot their arrows at him, piercing his skin. His blood drips down and colors the leaves of the earth below red and yellow, giving us the colors of autumn. Once the bear is wounded, he disappears and then reappears later. The hunters are still pursuing him across the giant dark sky.

THE FORMATION OF THE FINGER LAKES

There are actually eleven Finger Lakes, so named because they each have roughly the form of a finger. Two of the lakes are named after tribes of the six Iroquois Nations—Cayuga and Seneca Lakes. There is an Oneida Lake, but it is not a part of the Finger Lakes; rather, it lies farther east and is fatter and shorter than the others. One could almost imagine it to be the thumb

of the handprint. There are six major Finger Lakes. They are Skaneateles, Owasco, Cayuga, Seneca, Keuka and Canandaigua. Iroquois myth explains the creation of the Finger Lakes.

The Creator wished to bless the home of the Iroquois and he placed his immense hand upon the earth, and the impression it left was the Finger Lakes.

Non-Iroquois stories of the formation of the Finger Lakes include that they were formed on the spot where Paul Bunyan dragged his ax, or the spot on which the Blue Ox's horns stuck in the earth.

THE STORY OF THE STANDING STONE

In one version of the creation story, the Creator, Shukwayátisu, fashioned a number of dolls, with two in each set, a male and a female, using clay and water. First he made red ones, later yellow ones and black ones. His brother Flint asked if he could create some, and Shukwayátisu allowed him to come down from exile. Flint built a big fire and made white ashes; he mixed them with clay and water to make white dolls, but could not bring them to life. Shukwayátisu was able to do so, however, as he had given life to all of his six dolls. The white dolls also ran off to play as the other sets had.

One day, the Creator decided to speak to all the people of earth—the red, yellow, black and white people who had been created from clay. He gave all of them instructions on what they should be doing and told them to listen well, for he would only say it once. Then the Creator intended to return to Sky World, and the people would have to take care of the earth below.

The Creator spoke as he stood on a particular stone. However, though everyone listened, the people of the world all heard different things, and when the Creator left, they began to fight among themselves. At last, the Creator was forced to return and separate the people by color to different parts of the world. The red ones remained on the original land. It was said the different peoples needed to be separated so that they could all mature, and one day join each other again. It was also said that one day Flint would try to rejoin the people prematurely, and this, some say, is what happened in 1492. Now, though the people are together, they are not yet mature.

The story of the Standing Stone tells us that as the Oneida People moved from place to place, they were followed by the stone the Creator had stood on to address the world. As was their custom, the Oneidas would form a

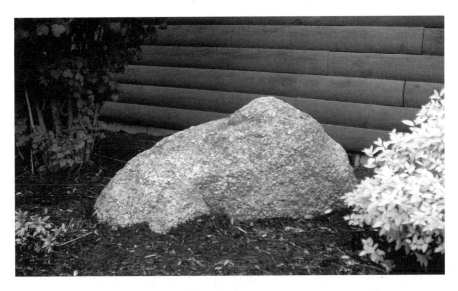

This is the stone on which the Creator stood as he spoke to all the peoples of the earth. Later, the stone followed the Oneida Indians each time their community relocated until 1849, when they placed it in the Forest Hill Cemetery in Utica for safekeeping. Today it stands in front of their council house, blending naturally with the landscaping. *Courtesy of the author.*

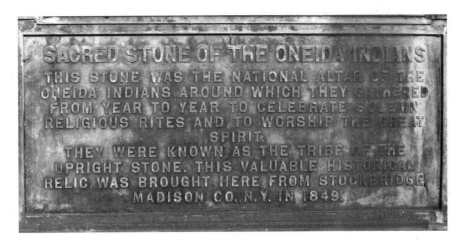

This is the bronze plaque located on the marble base where the standing stone remained in the cemetery from the mid-1800s until the 1980s, when it was removed to its current location. In the spring of 1902, the cemetery placed the boulder on a Westerly marble base and affixed a bronze plate to the base. *Courtesy of the author.*

village and live there for a number of years, and then relocate, perhaps ten miles away. The stone would always appear in their new community unaided by human hands no matter where they went. The Oneidas became known as the People of the Standing Stone.

In 1849, the Oneidas decided to find a new protected home for their sacred stone. They did not want the location to be on private land where ownership would change. At last, it was decided to remove the stone to Forest Hill Cemetery in Utica, New York, where it might remain safe and venerated. According to Jesse Cornplanter, in the autumn of 1849 the stone was loaded onto a wagon drawn by four horses. The trip to the cemetery was made with great difficulty, and the stone was accompanied by two trustees of the Forest Hill Cemetery Association, and a delegation of Oneida Indians. The boulder was placed near the cemetery entrance.

In the spring of 1902, the cemetery placed the boulder on a Westerly marble base and affixed a bronze plate to the base which bears this inscription:

SACRED STONE OF THE ONEIDA INDIANS
THIS STONE WAS THE NATIONAL ALTAR OF THE ONEIDA INDIAN, AROUND WHICH THEY GATHERED FROM YEAR TO YEAR TO CELEBRATE SOLEMN RELIGIOUS RITES AND TO WORSHIP THE GREAT SPIRIT. THEY WERE KNOWN AS THE PEOPLE OF THE UPRIGHT STONE. THIS VALUABLE HISTORICAL RELIC WAS BROUGHT HERE FROM STOCKBRIDGE, MADISON COUNTY, N.Y. IN 1849.

The sacred stone was removed from the Forest Hill Cemetery about 1987 and placed outside the new council house on the Oneida Nation Territory. It is not an exceptionally large stone, though without the aid of a wheel, it certainly would have been difficult to transport the stone from one location to another. According to a cemetery worker who helped move the stone, the Oneidas were offered the base with the bronze plaque as well, but they did not wish to take them. The base and the plaque remain just inside the entrance of the Forest Hill Cemetery even today. The cemetery was located off Oneida Street in Utica, not far from the New Hartford border. According to Kandice Watson at the Oneida Indian Nation Shako:wi Cultural Center, the Standing Stone was never used by the Oneidas as a national altar as indicated by the plaque.

HIAWATHA AND THE PEACEMAKER

Though the name Hiawatha is familiar to many Americans, the actual story of his life is known to far fewer. In the 1800s, Henry Schoolcraft wrote a work entitled *The Myth of Hiawatha*; however, the title was a misnomer. The actual character "Hiawatha" was based on a Chippewa god named Manabozho. The error was popularized when Henry Wadsworth Longfellow based his poem "The Song of Hiawatha" on Schoolcraft's work. The "Song of Hiawatha" sold over a million copies, etching the error indelibly on the American memory.

In reality, Hiawatha was an Iroquois man who lived long ago. Some estimates place him in the fifteenth century, and some say he lived much farther in the past. It is rather difficult to be sure when he walked the earth since the Iroquois did not have a precise dating system. Nonetheless, it is known through Iroquois oral history that Hiawatha was a skillful orator and perhaps a chief among the Onondaga, and that he had a wife and several daughters.

During Hiawatha's time, as in previous times, there was much warring among the five Iroquois Nations. The Iroquois Nations included the Senecas to the far west in present New York State, then the Cayugas. The Onondaga Nation lies in a more central location, around what is now Syracuse, New York. To the east of them were the Oneidas. Finally, the Mohawks held the easternmost position among the Iroquois. In addition to tribal warring and fights over hunting grounds, blood feuds were prevalent. As with many tribal peoples, when one person was murdered, the family of the murdered one was obliged to take revenge by killing the murderer. If that person could not be found, another life might be taken instead from that person's extended family. That family, in retaliation would seek revenge in turn and so the cycle of killing seemed without end. Hiawatha, however, believed in peace and friendship and spoke of these ideas with beautiful words to his people. Some of them believed in what he said and hoped for a time when there would be an end to the continual bloodshed the Iroquois had endured.

But one man in particular did not accept Hiawatha's message of peace. He was Tha-do-da-ho (also called Adoharhoh and Ododarhoh) and he was believed by his people to be a great wizard, a possessor of evil magic. His evil was reflected in his appearance as well. Tha-do-da-ho was badly misshapen and deformed. His hair was composed of writhing snakes, and some say his fingertips were snake heads as well. His hands were like the hands of a turtle, and his feet were as large as bear claws. He inspired fear and awe in all, and in addition to using magic to control and harm others, he had a team

of assassins and spies to do his bidding. Tha-do-da-ho was a chief of great power, but his power came from creating fear in others. He did not believe in peace and opposed the great words of Hiawatha.

Tha-do-da-ho crushed Hiawatha's attempts to bring peace to his people on three separate occasions. The first time that Hiawatha held a council to talk about his ideas, Tha-do-da-ho stopped it, and shortly afterward, one of Hiawatha's daughters died. Many believed this was due to the magic of Tha-do-da-ho. Once again Hiawatha held a council, and Th-do-da-ho came to oppose him. Following this, Hiawatha's second daughter died. Hiawatha grieved, but felt he must try yet again. Some say he had only one daughter left. She was pregnant with a child, and she was the most beloved of his children. Hiawatha held a council and sent her to gather wood. The chiefs, including Tha-do-da-ho, gathered around the council fire, and an eagle flew overhead. Tha-do-da-ho indicated his men should shoot it down, and so they did. The eagle fell near Hiawatha's daughter and Tha-do-da-ho's men rushed to retrieve it, but trampled Hiawatha's daughter in the process. In the end, Hiawatha lost his wife and all his daughters. Nothing could contain his grief. It was so intense that no one could come near him. According to custom, Hiawatha would be obligated now to kill Tha-do-da-ho, but he wanted no part of that killing cycle, and so he headed south and then east, leaving his people. He lived among the wild places alone. He became a wanderer and a hermit. He moved in the direction of the Mohawk people.

One day he came to a lake filled with water fowl. He told the birds to fly away and they did, carrying the water of the lake with them. There on the bottom of the dry lake, Hiawatha found purple and white shells. He gathered them and strung them on rushes, making strings of beads. He made three strands of these special beads and he said this: If he ever found someone so full of grief, he would use these strings of beads to lift the darkness from that person. Those beads would act as words of comfort for the grieving. This is how the custom of creating condolence beads came to be. Soon Hiawatha would meet an unusual man with ideas like himself. That man's name was Deganawida, though now the Iroquois do not use his name but call him the Peacemaker instead.

Deganawida was not from one of the Iroquois Nations, but from a distantly related tribe they called the Wendots and that we call the Huron. He was born in what is now Canada. It was a dangerous time back then, so Deganawida's grandmother and mother left their village to live in the wild areas, hoping it would be less violent. Then, miraculously, Daganawida's mother became pregnant though she had never lain with a man. The grandmother asked her about this, and did not believe that her daughter

had become pregnant of her own accord At last, however, the grandmother had a vision that the Creator had given her daughter this special child who would end much killing and bring peace but also, as a result, would bring an end to his own people. Because of this prophecy, the grandmother tried to kill the child when it was born. She cut a hole in the ice on a lake and threw the baby into the freezing water, but no harm came to him and he did not freeze nor drown. She tried to kill Deganawida several other times, with no avail, and at last abandoned the idea, understanding the boy had some form of supernatural protection.

As Deganawida grew to be a young man, he did not turn violent, but spoke of peace to those around him; however, they did not listen, and at last he told his mother he would leave in his canoe to seek another nation, never to return. He told his mother and grandmother that if they wished to know if he was alive, they should go to a special tree and make a gash in it. If it bled, then they would know he had died without bringing peace. If it did not, they would know he was still well.

On his journey, Deganawida met a chief named Jikonsahseh. She was from another tribe that spoke a language similar to his. She offered Deganawida hospitality, and he told her about his great plans for peace. She believed in him and was the first to hear his message. Deganawida promised to put his plan into action, and asked her to work toward peace by refusing hospitality to warriors. She did promise this.

At last Deganawida arrived in the territory occupied by the Mohawks, and he took up residence there, speaking of peace and harmony among people. Deganawida had a speech defect and was not an eloquent speaker. Some listened and others disbelieved, so he told them he would prove his words by climbing on top of a huge pine tree overlooking the Mohawk River. He urged them to cut down the tree so he would fall into the rapidly moving waters below. They cut the tree and left him for dead. Night came and there was still no sight of Deganawida, but in the morning, smoke was seen rising from an unoccupied cabin and they peeked inside to see Daganawida preparing his breakfast. The Mohawks realized that Daganawida had an important message. They adopted him into their tribe and believed his words of peace and unity. Daganawida, they could see, was a clear-headed, wise and fair man.

One day, Hiawatha was spotted by a woman, who returned home and reported her sighting of a man in the woods. Deganawida heard this, and told the people that he should be brought in and treated like a guest.

Hiawatha told Deganawida of his loss and sorrow, and Deganawida told the others. Hiawatha told Deganawida that if another had his sorrows, he would console that person with the strings of shell beads to remove the

darkness. Deganawida took one of the strings from the pole and came to Hiawatha and said: "When a person has suffered a great loss caused by death and is grieving, the tears blind their eyes so they cannot see. With these words, I wipe away the tears from your eyes so that now you may see clearly."

Deganawida took the second strand of beads and said: "When a person has suffered a great loss caused by death and is grieving, there is an obstruction in their ears and they cannot hear. With these words, I remove the obstruction from your ears so you once again may have perfect hearing."

Then Deganawida took the third strand of beads and said: "When a person has suffered a great loss caused by death and is grieving, their throat is stopped and they cannot speak. With these words, I remove the obstruction from your throat so that you may speak and breathe freely."

And with these words the darkness was removed from Hiawatha. He regained his unclouded sight, clear hearing and unobstructed speech, and was filled with life once again.

Hiawatha and Deganawida spoke, and they realized that they believed in the same things. They decided to pursue peace and unity among the Iroquois together. Together, they made the laws of the Great Peace, and together they composed a peace song to sing to the twisted Tha-do-da-ho, whom they understood would be the biggest opponent of peace. Then they approached the Mohawk council about their plan to create a great house of peace. The Iroquois lived in what are known as longhouses. They were very long structures that housed an entire extended family. Deganawida and Hiawatha saw the way an extended family lived together in peace in a longhouse as a metaphor for the way the Iroquois Nations could live together in peace as one people. They hoped to build a longhouse where the representatives of the five nations could meet. The Mohawks accepted the plan, and adopted Hiawatha as one of their own.

Soon after, Hiawatha and Deganawida journeyed to meet the nearest nation, the Oneidas. They explained the idea to the chief, who told them he would answer them "tomorrow," which symbolically meant the following year. After much discussion, in a year, the Oneidas accepted the plan for peace.

Deganawida and Hiawatha headed next to the Onondagas. Tha-do-da-ho rejected the proposal as they had anticipated so the two continued westward to meet with the Cayuga Indians. Their leader promised to give word, and when they returned, the Cayugas also had accepted the proposal. Daganawida, Hiawatha and the chiefs of the Cayugas, Mohawks and Oneidas then returned to the Ononadagas to convince Tha-do-da-ho of the great

worth of the plan. Deganawida sang the Peace Song to Tha-do-da-ho while Hiawatha explained the law. Many great chiefs of the Onandagas believed in the peace. Only Tha-do-da-ho needed to have his mind straightened. Concessions were offered to Tha-do-da-ho to obtain his consent. It was said that the council meetings would be held at the Onondaga Nation, and that they would be the Fire-keepers. The Onondagas would call the meetings and declare decisions of the chiefs. As Deganawida sang and Hiawatha spoke, it is said the snakes ceased to move in Tha-do-da-ho's hair. His twisted body became straight and healthy and his mind became good. He accepted the plan. (The snakes in Tha-do-da-ho's hair are largely seen by the Iroquois as a metaphor for the evil thoughts that emanated from his mind. The name "Hiawatha" is thought to mean "he who combs," referring to Hiawatha's combing the serpents from Tha-do-da-ho's hair.) Now there was only one more people to convince—the Seneca.

The Senecas were a large nation, and often engaged in war. Many Senecas liked the plan of Great Peace, but two leaders disapproved. It was then that Hiawatha made concessions to them, granting the Seneca military control of the Iroquois Confederacy. With this, the Seneca agreed and the Great Peace was realized. As a confederacy, rather than five separate nations, the Iroquois gained great power. Later, the Tuscaroras came in 1722 from Virginia and North Carolina and they became the sixth nation in the Iroquois Confederacy. The Tuscaroras also spoke an Iroquoian language, but had fled north after warring and to escape settlers. This land became home to them as they joined the Iroquois Confederacy.

It is customary for Iroquois to refer to Deganawida as "the Peacemaker" in everyday speech rather than as "Deganawida." It is said that in times of strife, when his wisdom is needed, an Iroquois may go into the bushes and call the name "Deganawida," and he will return.

Blessed Kateri Tekakwitha

The National Kateri Shrine is located not far from the New York State Thruway in Fonda. Tekakwitha was born in 1656, the daughter of a Mohawk warrior and an Algonquin Christian mother. When Tekakwitha was four years old, her parents and brother died during a smallpox epidemic, and Tekakwitha herself was scarred and partially blinded. After this, it was difficult for Tekakwitha to see in the bright light of the day and often she was seen covering herself with a blanket to protect her eyes from the light.

After her parents' deaths, she was taken in by her uncle, a Turtle clan chief. Though they tried to wed her to a young man at an early age, she would hide from her suitors in cornfields and other secret places, wishing never to marry. Like her mother before her, she developed an interest in Christianity; however, her uncle opposed the religion of the people who had brought smallpox among them.

They say Tekakwitha was a caring girl, very shy, and hardworking even then. At last, one day, through circumstance, she was able to connect with the Jesuits and finally received baptism at age twenty on Easter Sunday in 1676 by a Jesuit father at a nearby spring. It was then she received the name "Kateri," meaning "Catherine."

But Kateri's uncle was vehemently opposed to Christianity, and she was mocked and tormented by the villagers. They refused to call her by her name, but referred to her as "Christian" instead. One day, Kateri's uncle sent a man into the longhouse with a hatchet to pretend to kill her. A village woman accused Kateri of sinning with her husband, and told Father de Lamberville this. He told Kateri of the punishments God had awaiting her, but she disregarded his words, explaining she had done nothing unvirtuous. The villagers accused Kateri of being a slacker as she did not work on Sunday, the Sabbath. They would hide all the food so she would not be able to eat, hoping she would leave to work in the fields. The Father instructed her that she leave and pray continually. Kateri feared leaving as she knew her uncle would not permit it, but at last the opportunity arose and Kateri was able to flee north with the companions of an Indian named Hot Ashes. Kateri arrived at the Mission of Sault in present-day Canada, where she would live out the final portion of her short life. The letter she carried with her as an introduction from Father de Lamberville read "I am sending you a treasure, guard it well!"

Kateri arrived in the fall of 1677 and was paired with Anastasia Tegonhatsihongo, a Mohawk woman who would act as Kateri's constant teacher. The two were inseparable and Kateri learned quickly and spent her days cutting wood and performing other chores while engrossed in God.

Kateri met a woman named Mary Theresa, an Oneida who had been married before coming, but as it had not been a marriage of the church, it was not recognized. Mary Theresa and Kateri both wished to live lives without marriage, wholly devoted to God. They regretted their prior lives before Christianity, and decided the need for penance through self-mortification. This was a secret decision, and not one promoted by the religious community at large. However, Anastasia had spoken to Kateri about Hell and the need

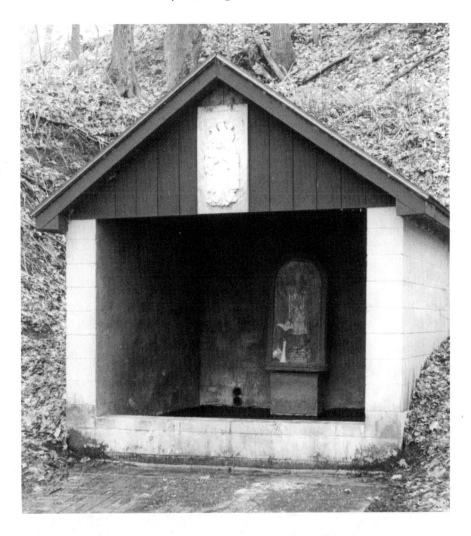

This sacred spring was the site of Kateri's baptism in 1676. *Courtesy of the author.*

for penance, and so the women embarked on such a program of their own invention.

The two soon met up with a third Christian woman, Mary Skarichions, and the three of them hoped to begin their own sisterhood on Heron Island, but the proposal was refused because of their youth and the distant location from the village.

Kateri renounced all clothing and ornamentation that she considered vanity, such as shell beads and beautiful blankets. Some of the austerities Kateri practiced included walking slowly on the jagged ice of the pond, and

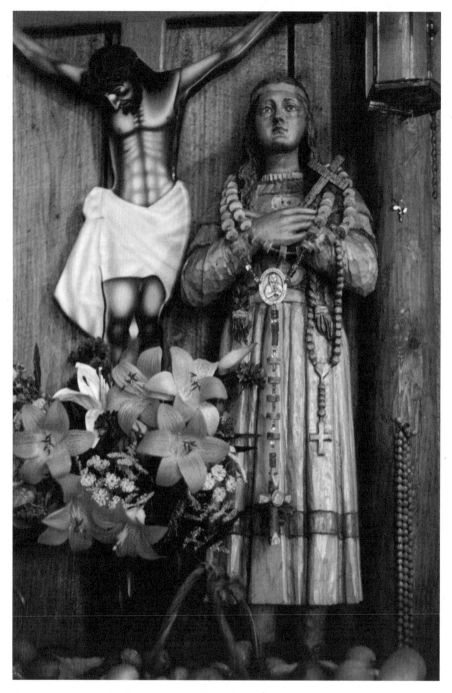

A wooden statue of the Blessed Kateri Tekakwitha inside her shrine. *Courtesy of the author.*

whipping herself with willow shoots. She would walk barefoot in knee-deep snow, and also wore a belt with iron spikes while she carried wood. She burned her legs with wood, and burned her feet with hot coals between her toes while saying the Hail Mary. She would eat sagamite with ashes during Lent. Mary and Kateri would go into the chapel alone, secure the door and whip each other until their shoulders were bloody, so great was their regret of their former Indian ways. They also practiced these devotions at an empty Frenchman's home in the middle of a cemetery. Sometimes, while being whipped, Kateri would say, "My Jesus, I must suffer with you. I love you, but I have offended you. It is to satisfy your justice I am here. Discharge, my God, on me your anger."

At last, Kateri fell very ill, and Mary went with Kateri's consent to Father Cholenec to confess their self-mortification. He was surprised and suggested that they had acted imprudently. She begged the Father to allow them to continue some penance and he allowed a few smaller austerities. Though ill, Kateri asked to fast during Holy Week. She slept on thorns to remind her of the Passion of the Lord, and died on the third day, weakened by the thorns, the fasting and her childhood smallpox, most likely. With Kateri's final breaths she uttered the words, "Jesus, Mary, I love you." Fifteen minutes after her death, the horrible scars left by smallpox in her youth vanished from her face, leaving it beautiful and unscarred. Kateri died at the young age of twenty-four years on Wednesday of Holy Week in the year 1680. Her death was witnessed by two Jesuits and a roomful of Indians who attended her bedside in her final moments. Following her death, many people reported cures and miracles.

Fifty years after Kateri passed on, an Indian convent was formed in Mexico, where the nuns prayed daily for Kateri to receive sainthood. These prayers are recited still.

Kateri Tekakwitha is known as the "Lily of the Mohawks," "the Genevieve of New France," "the Mohawk Maiden," "the Pure and Tender Lily" and "the Fairest Flower among True Men." She was beatified on June 22, 1980, by Pope John Paul II. Her attributes are the lily and the turtle as she was a member of the Turtle clan. She is a patron of ecology, and her feast date is June 14 in the United States. When she achieves sainthood, she will be the first Native American to do so.

The Mohawk village of Caughnawaga (meaning "by the rapids"), situated near the holy spring in which Kateri was baptized, is located at the site of the Kateri Shrine in Fonda. It is considered the best-preserved Mohawk village of its time. The shrine, maintained by Franciscan friars, is opened to the public part of the year when visitors are invited to visit the girlhood home

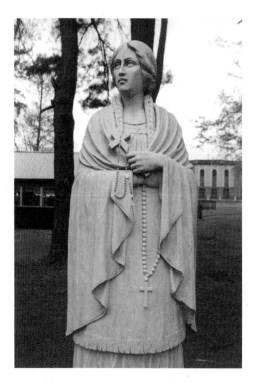

A statue of the Blessed Kateri in front of the Shrine of Our Lady of Martyrs. This site's location was the village where Kateri Tekakwitha was born. *Courtesy of the author.*

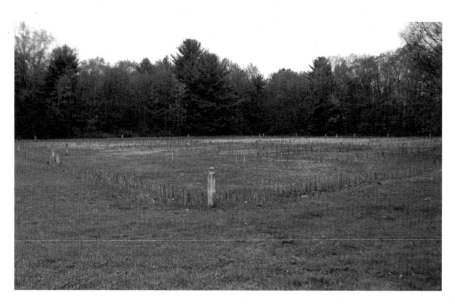

This site is on the property of the National Kateri Shrine in Fonda. The stakes indicate the locations of the longhouses in what is known as the Caughnawaga Castle Site, an archaeological Iroquois village that was thought to have existed at this location between 1666 and 1693. The cement posts indicate the corners of the wood wall surrounding the village. It is on the National Register of Historic Places. *Courtesy of the author.*

of the Blessed Kateri. Many have been cured by the water of the well, and through Blessed Kateri's intercession.

THE MARTYRDOM OF THREE JESUITS

Back when this area was known as New France, the Jesuits began a campaign to Christianize the natives. The Jesuits attempted to convert the Hurons because they were closest to the Quebec base of the Jesuits, and not as itinerant as the Algonquins. It was considered easier to learn their language and ways. The Iroquois, particularly the Mohawks, were frequently warring with these more northern tribes, and were particularly dreaded by natives and French alike.

The works of the Jesuits in New France are well-known since they were recorded in *The Jesuit Relations*. These reports spanned seventy-three volumes and were published and sold in France to raise money to support the Jesuit missionary works and to excite interest in their works by wealthy Parisians who might donate money to the Jesuit cause. *The Jesuit Relations* were eagerly read by many who awaited the latest news from the New World. But despite the diligent efforts of the missionaries, their conversion rate was *extremely* low. Often the Indians would only allow themselves to be baptized on their deathbeds, and this did not help toward the building of a vibrant congregation of converts. Often the blackrobes, as they were called, were thought to be sorcerers who demonstrated strange talents such as predicting celestial events and carried mysterious objects such as compasses and clocks, which were thought to be alive. They used writing and could repeat what a person said days after an event. However, the strongest reason for the aversion to the blackrobes appears to have been the spread of disease that seemed to follow them yet did not always seem to affect them. This, the bringing of disease to native peoples, was the most damning evidence of sorcery and often left them disliked and distrusted.

In all, there were eight North American Jesuit martyrs, three of which were martyred here in Central New York. These three martyrs, now sainted, are Jean de la Lande, Isaac Joques and René Goupil.

Father Isaac Joques arrived in September of 1636 at the Huron village of Ossossané. He was a redheaded man with a beard, born of a wealthy family, and had surgical skills and so was of particular value in the untamed wilderness. The Huron named him "Ondessonk," meaning "bird of prey." Disease soon swept the village, this time including the blackrobes, so charges

of sorcery were not leveled. Joques spent much time attending the ill after he, himself, recovered. Though people often accepted medical help, they rejected the Christian message. Some people believed that the blackrobes caused disease through baptism. They did, however, manage one conversion, that of a chief named Tsiouendaentaha and an elaborate baptism and ceremonial feast were given. Tsiouendaentaha was given the Christian name of Peter. A mission was built in the area to serve the people, but when disease began to spread again, the accusations resurfaced.

In 1642, the Iroquois were on the warpath again, and the Huron did not go to Three Rivers to trade, as was their custom. The Jesuits were hoping to travel south with the Huron, bringing medical supplies and other necessary goods to their mission. Still, the trip needed to be made and Jogues volunteered. Another man offered to go, a donné named René Goupil. Goupil had entered the Jesuit Novitiate at Paris and spent several months there, but was dismissed because he had a hearing difficulty. Undeterred, he journeyed to New France, where his impairment would not be a consideration. Here he would work as a donné. Donnés were men who were devoted to the Society of Jesus but were unable or unwilling to become priests. They served the missions, providing services such as growing crops, attending to the sick, hunting or defending the mission with arms. Goupil requested that he travel with Jogues to bring supplies to the mission.

Jogues and Goupil, who both were trained medically, were to travel by canoe in a series of twelve canoes with Huron escorts and another man named Guillaume Coûture, who was an interpreter. Clearly, the trip was dangerous, and both realized that death was a possibility. Midway between Three Rivers and where Montreal now stands, they were ambushed by Mohawk warriors bearing Dutch muskets. Jogues was thrown from his canoe into the tall grass and likely could have remained there undetected, but would not abandon his captured colleagues. Instead, he walked to the warrior holding Goupil, and as three Mohawks ran toward him, he told them to take him prisoner with the others. There were twenty-three captives and the Bear clan took the supplies meant for the mission. The prisoners were moved for several days, and on the fourth day, Goupil asked to take the vows of the Society of Jesus.

They were taken to an island on Lake Champlain, where the Mohawks were heard beating their canoe paddles and firing muskets. The men were forced to run the gauntlet and were beaten severely with clubs and sticks. Subsequently, they were attacked with knives and stones. Many of the captives had their fingernails ripped out, or parts of fingers cut off. The men were tortured with hot irons and hot coals. Then they were taken to the

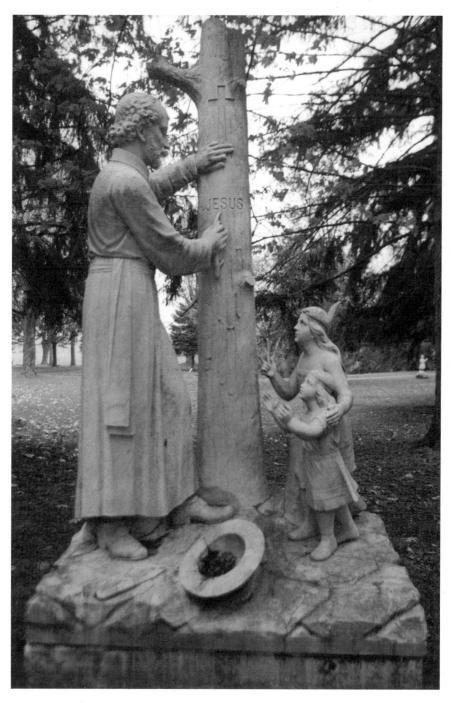

Statue of St. Isaac Joques, a Jesuit martyr tortured and killed by Mohawk Indians here. This statue is located outside the Shrine of Our Lady of Martyrs. *Courtesy of the author.*

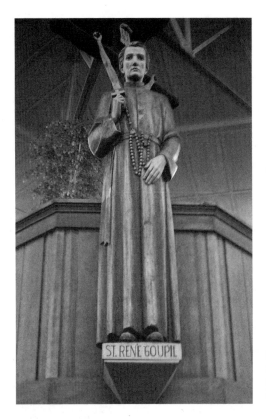

ST. RENE GOUPIL

St. René Goupil, one of the Jesuits martyred at Ossernenon, located in modern-day Auriesville. *Courtesy of Francis Zimmer.*

Mohawk village of Ossernenon, which lay where the village of Auriesville stands today. Jogues was tied up, hanging from his joints from a doorway, while the others were left to dehydrate on a stage. However, a guest saw Jogues and demanded he be cut down, and hospitality required honoring the guest's request.

Jogues knew two of his party would be killed soon, so he baptized them. It was announced that Jogues and Goupil would die the next day; however, there was some delay in the killing of the prisoners since some parties believed it would damage their relationship with the French. Sentences were decided for the prisoners, but Jogues and Goupil's fates were yet uncertain. They were given some menial tasks to perform around the house, and Goupil would quietly pray as he worked. The old Mohawk who lived there was certain Goupil was calling upon evil spirits and Jogues warned Goupil against this, but it was so ingrained in Goupil that he did not cease. One day, Goupil removed his cap and laid it on the head of a youth and made the sign of a cross over it. This sealed Goupil's death sentence. Later, as Jogues and Goupil were praying near the forest, they were called back. The

two men knew something was amiss. As they walked to the gate, a Mohawk threw a tomahawk into Goupil's head and Joques rushed to give Goupil absolution. Then Goupil was struck several more times until he was dead. Though Goupil was murdered, Jogues remained alive.

Later, Jogues secretly left the safety of the longhouse to search for Goupil and at last found his body in the ravine. He weighted it with stones under the water so no one would find it until he came back to bury his friend's sacred remains, but before Jogues returned, the body had been found and was hidden in the bushes, where animals had gnawed at it.

Jogues remained alive, and was given chores to perform. One day he was taken fishing with a group below Fort Orange. The party traveled to Rensselaerswyck to trade with the Dutch. The Dutch had previously tried to ransom Jogues unsuccessfully, and now a Dutchman offered to help him escape. Joques was hidden inside the hold of a ship, but decided to return to land despite the danger. At last, the Dutch paid a ransom for Jogues and he was put on a ship headed for Europe. When finally arriving in France, Jogues went to the Jesuit College and spoke to the rector. Jogues insisted that he return to Quebec, and was on a ship sailing back after only a brief stay in his homeland. While in France, Jogues had been startled to learn that all of France was aware of his North American experiences through the *Jesuit Relations*. He was, in fact, famous, but nonetheless chose to return to North America to continue his missionary duties.

In 1645, after his return, the Iroquois had agreed to participate in peace negotiations with the French. Two of the Mohawks who came as envoys were two that had tortured Jogues previously, and they refused to make eye contact with him. After much ceremony, Jogues was asked by the Mohawks to return to Ossernenon as an envoy of peace. This was a peace treaty with the Mohawks alone. None of the other Iroquois nations had decided to participate in a treaty with the French. Coûture would return to the Mohawks also. Jogues planned to bring peace and create a new mission there. Jogues began having nightmares about returning, and Coûture also had misgivings. Coûture asked to be released from his vows, and was. He remained in Quebec. Instead, Jogues would travel to the Mohawks with Jean Bourdon to seal the peace compact.

On May 2, 1646, Jogues left, wearing leggings and a doublet instead of his usual black robe because he was advised that this would help ensure his safety and create less animosity. Once he began to approach Ossernenon, he felt tremendous anxiety. The Mohawks accepted the peace offerings of the French, while snubbing those of the Algonquins, and suggested Jogues return home rather than stay.

The sanctuary of the Shrine of Our Lady of Martyrs. *Courtesy of Francis Zimmer.*

In August, it was announced that Jogues was to return again as a peace envoy. Now, premonitions of his death strangely left him peaceful. This time, donné Jean de la Lande would travel with him. They left in two canoes— one with Jogues, de la Lande and an Iroquois, and one with three Hurons, who were traveling to visit imprisoned relations. As Jogue intended to start a mission, he dressed in his traditional black robe.

As they traveled, word arrived that the Iroquois were attacking the Hurons and so the three Hurons turned back. The rest continued on. They were ambushed by Mohawks of the Bear clan, painted for war, who threatened their lives. De la Lande and Jogues were stripped and bloodied. As they entered Ossernenon, the people cried death threats and called them demons. Perhaps they would have died at that point were it not for Jogues's adopted aunt, who took them to her longhouse where they would remain untouchable by the throngs.

During their absence, there had been crop failures and disease, which the Mohawks attributed to the blackrobes and the mass box that Jogues had left at his aunt's longhouse, which they believed contained evil spirits.

A council meeting was held to determine the status of the peace. Though the Turtle and the Wolf clan hoped to honor their treaty with the French, the Bear clan would not.

On October 18, 1646, while Jogues was in his aunt's longhouse, he heard someone calling to him outside and inviting him to a feast. Jogues sensed this was a trap and that harm would come to him once he left the longhouse,

but it would be unspeakably discourteous not to accept an invitation, so he followed the man to a house, where he could hear many men hidden inside. As he bent to enter the longhouse, a tomahawk split his skull, and then the men danced and celebrated his death.

De la Lande wondered why Jogues had been away so long and feared the worst. Jogues's aunt explained in tears how Jogues had been killed.

That night, de la Lande decided to find the sacred body, crucifix and rosary of his fellow so he could return with them to Quebec. Under the cover of darkness, he crept from the cabin, but soon heard footsteps behind him. Someone grabbed him by the throat, dragged him to an open area and then split his skull with a tomahawk.

Jogues's and de la Lande's heads were impaled for display and their bodies tossed into the river.

In 1930, Pope Pius XI canonized all eight North American Martyrs. René Goupil is considered the patron saint of anesthetists. The feast day of the North American Martyrs is on October 19.

THE STRANGE STORY OF ELEAZER WILLIAMS, THE DAUPHIN OF FRANCE

A number of Oneida Indians decided to follow a missionary of mixed Indian and white ancestry west to present-day Wisconsin, which was then a part of the territory of Michigan. The man they followed was Reverend Eleazer Williams, who later came to believe that he was the last dauphin of France, who was proclaimed at age eight to be Louis XVII, king of France. Eleazer Williams was mocked by Mark Twain in his book *Huckleberry Finn* when Twain describes a con man claiming to be the dauphin. Here is the story of Eleazer Williams.

Eleazer Williams's own family's history is quite remarkable, perhaps more so than his invented history because it is, in fact, true. The Caughnawaga Williams lived in the town of Deerfield, located in the Pocumtuk Valley in Western Massachusetts. The area had been settled in 1669, but had fallen victim to Indian raids and was abandoned. It was rebuilt by the year 1704 and surrounded by a strong stockade and fortifications. Deerfield seemed untroubled since its resettlement, and on the night of February 28, 1704, there was a heavy snowfall. The sentry abandoned his post, lured by the warmth

Mark Twain's study in Elmira. *Courtesy of the author.*

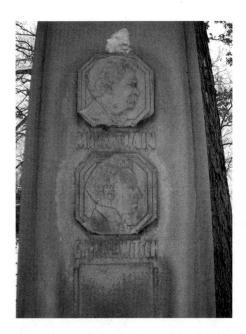

Mark Twain's grave site in Woodlawn National Cemetery in Elmira. *Courtesy of the author.*

of his bed. However, all was not well. The four feet of snow that had been deposited rose near the top of the stockade and had become hardened into a tough crust, making it possible for men to walk over Deerfield's stockade. That night, Major Hertel de Rouville led more than three hundred French and Indians north of Deerfield and silently entered the town. Suddenly the attack began as doors were knocked down and Indian warriors sounded their attack.

The first home that was invaded belonged to the town's leader, the Reverend John Williams. Williams was overcome by the strength of his attackers, and his two youngest children were tomahawked. Williams, his wife and 5 of his children were taken captive along with 110 others from the town, and forced to march through the freezing winter air to Canada—those who moved slowly were killed. Reverend Williams's wife Eunice met her death in that way, never arriving in Canada. The town of Deerfield was torched.

At last, Reverend Williams was exchanged and returned to Boston, eventually making his way back to Deerfield. Though he tried, Williams was unable to have his daughter Eunice freed. Instead, she remained in the village of Caughnawaga, close to Montreal. Eunice began, eventually, to live like an Indian, forgetting her native tongue and wearing Indian clothing. She became a Roman Catholic, married a man of French and

Indian descent and bore three children. One of her offspring was named Mary.

Mary, the daughter of the captured Eunice, bore a son named Te-ho-ra-gwa-ne-gen, otherwise known as Thomas Williams. As parentage was traced through the mother in the Native American culture, the son retained the mother's maiden name. This Thomas Williams became a chief and accomplished many notable deeds, such as accompanying Burgoyne to Bennington and Saratoga, and accompanying Sir John Johnson to the Mohawk Valley. He served on a variety of commissions for the Canadian government. After 1812, he aided the Americans, preventing the Caughnawagas from joining with British forces.

Thomas Williams wed an Indian named Mary Ann Rice and together they bore numerous children, one of whom was Eleazer Williams. In 1800, Mr. Nathanial Ely and his wife, who was a cousin to Williams, took Eleazer and his brother John into their home in Springfield to give the boys an education. While John only stayed several years before begging to return to his Indian home, Eleazer stayed with Mr. Ely for eight years and became a voracious reader. Eleazer was a quiet boy and an exceptional student.

Upon the death of Mr. Ely, Eleazer went to live with Reverend Enoch Hale in Westhampton, Massachusetts. It was there that Eleazer began studying for missionary work among the Indians.

During the War of 1812, Eleazer Williams was appointed general superintendent of the Northern Indian Department to prevent border Indians from joining forces with the British. Williams is thought to have been responsible for preventing the St. Regis and Caughnawaga Indians from fighting against the young United States. Williams was also soldiering in the military and was wounded at the Battle of Plattsburg.

After the war ended, Williams again considered ministering to the Indians. Though he had been reared a Roman Catholic in the tradition that began with Eunice, and had received a Congregational education, Eleazer decided to pursue a missionary career as a Protestant Episcopal missionary because he believed, among other things, that the Episcopal Church's ritual services would resonate better with those of the Indians to whom he would minister. Bishop Hobart appointed him as a catechist and lay missionary in 1816 to the Oneida Indians at Oneida Castle, New York.

Williams was a powerful orator and proficient in the Oneida language, allowing him to preach directly to the congregation rather than through an interpreter. He was immediately successful. Upon his arrival in 1816, the Oneida Indians were divided into two distinct political and religious parties. One party, known as the Christian Party, consisted of the Indians

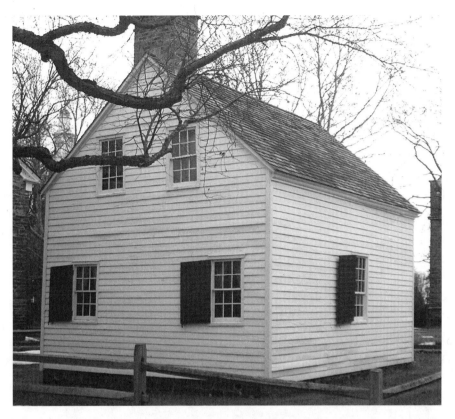

The home of Reverend Samuel Kirkland, built one fall while living with the Oneida Indians. It stands on the campus of Hamilton College in Clinton, New York. *Courtesy of the author.*

who had previously been converted to Christianity by the Reverend Samuel Kirkland. These Indians were Christians, though not necessarily enthusiastic ones. The second party was known as the Pagan Party and consisted of the unbaptized Indians who pursued their native religion and wished no part of Christianity. When Williams arrived, the members of the Christian Party attended services and were soon invigorated by Williams's oratory. Soon after, members of the Pagan Party began to convert to Christianity. After only a year, practically all Oneida Indians were baptized Christians, and the Pagan Party ceased to exist as a religious group, changing their name to the "Second Christian Party" and announcing the change to Governor DeWitt Clinton by letter. Now the entire Oneida Nation was of one religious order, though the two parties still varied politically.

In the year 1818, Bishop Hobart visited Oneida Castle. At that time, there was a chapel under construction and eighty-nine confirmed Indians. The

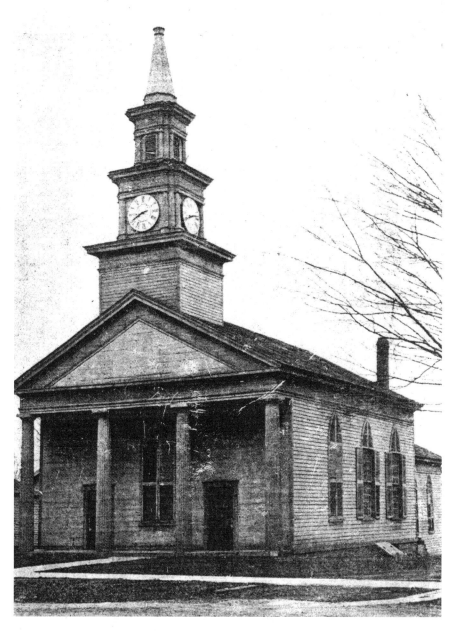

Eleazer William's Oneida Castle Church was called St. Peter's. This structure was later purchased by the Unitarians and brought to the village of Vernon, where it served as their church building. Later, it became the Vernon Town Hall. Finally, it was torn down to make way for the new firehouse. *Courtesy of the Vernon Historical Society.*

chapel became known as St. Peter's Church. During Mr. Williams's four years in Oneida Castle, he spent much time ministering to the Oneidas, and also rendered translations of the Gospels, hymns and the Common Book of Prayer into Mohawk. He worked with the Oneida language to enable children to learn to read it easily. Mr. Williams had a choir of Indian boys and infused the services with impressive ritual, dressing in a white collar (though he was not ordained). Through his works, he won the hearts of the Oneida people.

During the period in which Williams was stationed in Oneida Castle, the local white population had increased dramatically, and the Federal government decided the Oneidas should be moved westward. Should this happen, Mr. Thomas Ogden, head of the New York Land Company, stood to profit from the vacated land. Other proponents of the westward relocation of the Indians were Bishop Hobart and Eleazer Williams. The idea was to move the Indians west to land that then lay in the territory of Michigan, but which today stands in the state of Wisconsin around the Green Bay area. The U.S. government understood that Williams was likely to be their best promoter of this movement. Williams dreamed of establishing an enormous theocratic Indian Empire in the West composed of all six Iroquois nations with himself in charge.

Tracts of land were granted by the Wisconsin Indians, the Winnebagas, Menomonees and the Pottawatomies, and, over a span of years, a segment of the Oneida Indians, the Brothertown Indians and the Stockbridge Indians moved to the area. The other Iroquois Nations disregarded Williams's call. Many Oneida Indians were offended by Williams's decision that the Iroquois should be moved and distanced themselves from Williams, thinking of him as a great betrayer.

Williams made his residence in present-day Wisconsin in the Green Bay area, and opened a school there. Williams was thirty years old when he fancied a lovely fourteen-year-old student who was French and Menomonee Indian. Her name was Madeline Jourdan and she was already engaged to a man who was away traveling. Williams approached the girl's mother, offering gifts, and the mother promised Madeline to him. Madeline Jourdan first learned of her marriage to Williams when her mother told her not to attend school one day because she was to marry the reverend that very day, on March 3, 1823. With Jourdan came a dowry of five thousand acres of land from the Monomonee Indians.

Because of the great discontent caused by Williams's moving some of the Indians west, and because of irregularities in finances caused by Williams's neglect, a petition was sent to the Missionary Society of the Episcopal

Church requesting that Williams be removed from office. However, Williams was not removed at that time; rather, he was ordained as a deacon by Bishop Hobart at St. Peter's Church in Oneida Castle, in the heart of his opposition. Charges were withdrawn against Williams.

After this, Williams returned to Green Bay to work for several years as the leader of the relocated Indians in that vicinity. He attempted to build colleges and schools for his people, but with little success. He encountered more and more opposition and resigned his post in 1831, though he continued to have interest in Indian affairs, and traveled frequently to Washington to serve in that regard.

Ten years after his resignation, Williams visited the St. Regis Reservation in New York in order to establish a Protestant school there. He received word from his agent in New York City, Mr. Thomas Ogden, that the Prince de Joinville, the son of Louis Phillipe, was traveling to Green Bay and had requested to meet Williams. Williams returned to Green Bay to see him. The nature of that meeting was not known until many years later, but it would become a centerpiece for Williams's later claim to royal birth.

In 1853, a supposed Reverend John H. Hanson published an article in Putnam's Magazine called "Have We a Bourbon Among Us?" The content of Mr. Hanson's claims are described hereafter. That story describes explicitly how the dauphin came to be in America in the very person of Eleazer Williams.

Prince Louis Charles was the second son of King Louis XVI and Marie Antoinette, and the young prince became the dauphin in 1789 upon the death of his elder brother. Upon the storming of Versailles, the royal family was imprisoned in the Tuileries, and later they were reincarcerated in the Temple after the Tuileries fell. In 1803, the dauphin was removed from his family to be kept in his own cell, where he was watched by Simon, a jailer who at one point tore a towel from the wall and beat the boy over the head, cutting him over the left eye and by the nose with a nail embedded in the towel. Here, the boy endured profanity, beatings and debauchery, and was forced to sing obscene songs about his mother, Marie Antoinette. The boy's mind and body began to fail him, but he nonetheless survived and eventually Simon was sent to the guillotine with Robespierre.

Next, the dauphin was confined to a windowless, lightless room without sanitary facilities. He lived in filth and deteriorated further until, at last, a new guardian, Laurent, ordered the child to be placed in yet another room and cleaned. Another man, a M. Gomen, was also appointed to care for the boy. He was thought to be a Royalist and acquainted with the dauphin's uncle, the Duc de Provence.

Laurent left his position and Etienne Lasne was appointed guardian. He also had seen the dauphin at the Tuileries and had been friendly with him.

By now, the young boy had deteriorated greatly, suffering from emaciation and a variety of sores and tumors. He was unable to speak for long stretches of time and his mind was, for the most part, unable to function. At last a physician, M. Dessault, who had been the royal family's private doctor, was appointed to the boy's care. He diagnosed the boy with "a slight taint of scrofula," starvation and the effects of unsanitary conditions. Dessault attended the boy for nearly a month, until May 30, when Dessault died suddenly, arousing the suspicion that he had been poisoned. During the month of Dessault's care, a commission had reported to the convention that they had seen the boy, who was "idiotic, emaciated and had tumors on both knees, both wrists, and both elbows."

On the day that Dessault died, the commissioner in charge of the Temple was M. Bellanger, who had ties to the Duc de Province. Bellanger reputedly spent an entire day with the dauphin, making sketches and amusing the boy.

On June 5, surgeon M. Pelletan was ordered to attend to the boy, and a M. Dumangin was assigned to assist. Both these men were unfamiliar with the child. After three days, the boy in the Temple died. The autopsy revealed the boy had a tumor on the right knee and another on the left wrist. The boy was buried in the cemetery at l'Eglese St. Marguarite.

But, Mr. Hanson asks his readers, "was this child who died at the Temple truly the Dauphin?" He thinks not! Mr. Hanson explains that M. Bellanger, protégé to the Duc de Provence, spent an entire day with the child against Temple procedure. The next day, M. Dessault, who knew the dauphin, died of mysterious circumstances. The two men who pronounced the dauphin dead were unfamiliar with his appearance and the tumors described in the autopsy do not match all the locations of tumors previously reported to the convention not long before. Furthermore, during the boy's last week alive, he became quite talkative even though the boy had been unable to speak for months previously.

The very day the child died in the Temple, Hanson explains, a police bulletin was issued stating that a member of the royal family had escaped. All vehicles traveling with children in France were ordered to be detained. Mr. Hanson surmises that a sickly child with tuberculosis was substituted by M. Bellanger for the dauphin, while the true dauphin was smuggled out of the country and to New York State.

This story prompted much discussion and created a great stir among certain circles in America. It became the subject of much speculation

in the papers on both sides of the issue. The people near Green Bay, Wisconsin, scoffed at claims that Williams was the lost dauphin. After all, Williams was of mixed Indian and white blood and had a swarthy appearance, quite unlike the fair complexions of the French royal family. Additionally, he had living parents whom he resembled greatly and playmates who remembered Williams from his earliest days. Nonetheless, many people in the Eastern United States took to the romantic idea of Williams as the mysterious missing dauphin. Those proponents wined and dined him, paying him much attention and, in fact, treating him royally despite the evidence that he was, in fact, an imposter.

Though the story appeared to be published by a Mr. Hanson, in 1872 a statement was taken from a Colonel Eastman. In Green Bay, Eastman had developed an interest in the Bourbon family and began studying French history and writing a work of fiction about the whereabouts of the dauphin. He knew Williams and named the main character after him. The whole story was created entirely from his mind and knowledge of French history, Eastman says. Williams liked the story, so Major Eastman lent him the work to read during the summer of 1847 and the winter of 1848. However, Williams copied the work and Eastman did not learn of it until one day in 1853, when he entered Burley Follet's book store in Green Bay and found the story published in Putnam's Magazine, written in Eastman's own words.

When the Prince de Joinville heard of the controversy, his secretary declared the whole story false. The prince had met a passenger, and had an interesting discussion of the area's early French history with the man and nothing more. There had never been a private conference or any mention that a Mr. Williams might be the missing dauphin. Nor was there any intimation that Williams had any connection to the French throne. The prince had certainly never offered Williams abdication papers, as claimed.

After Williams's death, papers were found among his belongings, including a manifesto outlining the course of action he would take in the event that he was called upon to take the French throne.

St. Peter's Church, the church that Eleazer William and his congregation built about 1818 in Oneida Castle, was eventually moved by the Unitarians to the nearby village of Vernon. It was carefully deconstructed and reassembled on the Seneca Turnpike, now Route 5. While the Methodist church was having some reconstruction, the backside of the Methodist Church across the street from it was torn off and added to the back of the Unitarian Church across the street as an addition. The people said it was the only time the Methodists and Unitarians have ever been joined.

Eventually, the Unitarians sold the church to the Town of Vernon, and it became the town hall for many years. Later, the town hall was torn down to build the fire department building—a squat, brick structure that still exists—in its place. Outside, near the sidewalk, is a pole with a historic marker on it, a reminder that that spot was where the Indian Church had been moved from Oneida Castle.

BUFFALO BILL'S WILD WEST SHOW AND THE ONEIDA INDIANS

Buffalo Bill Cody began staging large, outdoor exhibitions about 1882 that often featured horses, wagon trains, buffalo, rodeo elements, racing and sharpshooting. His shows often tried to recreate historical events in a romantic and dramatic way, usually portraying himself as the hero. Scenes might be those of settlers defending their homesteads, pioneers fending off an Indian raid and defending their wagon train or a significant battle such as that of Little Big Horn. Usually there were a number of real Indian actors involved in the show, sometimes Indians of great note such as Chief Sitting Bull, Chief Joseph, Geronimo and Rains in the Face, who reputedly killed General Custard. The Indians were usually portrayed as savage and uncivilized, while Buffalo Bill assumed the role of the hero, romanticizing his earlier role in various Indian battles and his role as scout. It is said that though the Indians were portrayed in a negative light during the shows, they were treated with great respect and paid well by Buffalo Bill Cody.

In 1891, Buffalo Bill's Wild West show came to Utica, New York, and six free passes to the show were handed out to Oneida Indians. While the Indians were at the show, twenty-eight deputy sheriffs descended on the Oneida Indian homes, tossing their furniture out into the street in an attempt to take their homes. Later, some of the Oneidas were able to retake their homes. Others are believed to have passed into the hands of settlers.

Tickets to the Buffalo Bill Wild West Show were distributed to Oneidas as a ruse to remove them from their properties. Color lithograph, circa 1870. *Courtesy of the Library of Congress Prints and Photographs Division.*

Part II

THE REVOLUTIONARY WAR PERIOD

Chief Skenandoah

During the Revolutionary War, of the Iroquois, only the Oneida Indian tribe sided with the Revolutionary forces. This decision to side with the colonials was greatly influenced by two men. One was missionary Samuel Kirkland and the other was the Oneida Indian Chief Skenandoah, who was to become renowned for his part in the war as well as his extraordinary age upon his death (some place it at 110 years old).

The story of Skenandoah is recorded in history and song. Song was a way the Iroquois reproduced and remembered their oral history, and Iroquois oral history recounts a remarkable tale of the man known as Skenandoah.

The name "Skenandoah" may be found spelled a variety of ways, often depending on which Iroquois nation used it. "Skenandoah" is usually seen as the Oneida spelling, but the Mohawks use "Shenadoah" and there are other variations as well. "Skenandoah" is believed to mean "like a deer" and refers to an instance in Skenandoah's life when he fell in love with a clan sister. Such a relationship is forbidden, and so they met secretly, like a deer. Skenandoah is not only remembered for his battle record, and incredible longevity, but also for his conversion to Christianity. In 1754, Skenandoah was at the Albany Treaty Conference. A great celebration followed at which Skenandoah imbibed too much alcohol and was mortified in the morning by his drunken behavior from the night before. Some say he awoke without clothing. Skenandoah swore off liquor.

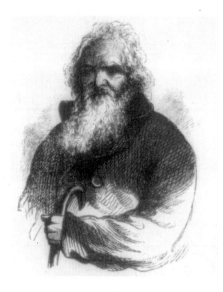

Left: "Skandogh, the Old Oneida Chief." Skenandoah's name is spelled a variety of ways. This 1856 engraving shows the chief as an aged man. He is thought to have lived over a hundred years. *Frank Leslie's Illustrated Newspaper*. Wood engraving from ambrotype by Whitney, Rochester, New York. *Courtesy of the Library of Congress Prints and Photographs Division*.

Right: Reverend Samuel Kirkland. Oil on canvas by Augustus Rockwell, circa 1870s. *Courtesy of Hamilton College*.

Later, in 1764, the Reverend Samuel Kirkland arrived at Oneida Castle to serve as a missionary to the Oneidas. Kirkland preached abstinence and strict moral values. These words had great appeal to Skenandoah because of his experience at the Albany conference. The two men became great friends, and, perhaps in part because of Skenandoah's example, Kirkland was able to convert half the Oneida tribe to Christianity. The second half was converted much later by the aforementioned Eleazer Williams. Skenandoah and Kirkland grew so close that they were buried next to each other, and their markers remain in Hamilton College's cemetery even to this day. Skenandoah became known as "the white man's friend."

According to the oral tradition in what is known as "Skenandoah's Song," as colonists began to arrive in greater and greater numbers, the Iroquois would send people to those they saw as great learners, ones who would imbibe new materials and ways. Sometimes these were young colonists. An Indian would go to that person again and again to question them, to open their minds to new thoughts and ideas. Among the people "Skenandoah's Song" tells us were educated in this way were Benjamin Franklin, as well as

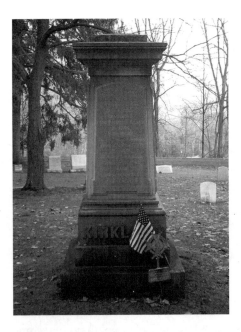 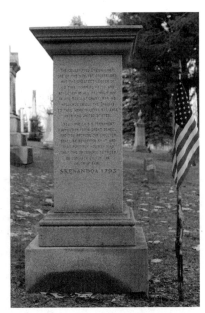

Left: Samuel Kirkland's marker in the cemetery at Hamilton College, site of the school he founded. *Courtesy of the author.*

Right: Skenandoah's marker. Skenandoah is buried on the Hamilton College campus close to his friend, Reverend Samuel Kirkland. *Courtesy of the author.*

Abigail and John Adams. There were many others whose names are not recalled. Oral tradition tells us that Benjamin Franklin was taught to swim by a Mohawk Indian under the cover of fog so they would not be discovered. Franklin later used his skill to impress people in Europe, showing them how a man could move on the water without the aid of a boat.

It is recounted in "Skenandoah's Song" that Skenandoah was asked by another Indian to watch Benjamin Franklin in Boston, who was known for his great mind. Skenandoah would travel alone sometimes, or bring with him another who was more adept at English. Generally, communication went smoothly as he and Franklin understood each other deeply. One day Franklin requested Skenandoah send some men to help Colonel Washington and his troops locate food for provisions at the beginning of the French and Indian War. Iroquois were sent and acted as guides to them. Washington was aide-de-camp to General Edward Braddock, who was most familiar with European open field–style battles. Braddock was arrogant and failed to listen to advice about fighting in heavily wooded terrain. Because of this, the Iroquois gave Braddock the name Never Listens. The Iroquois recall in "Skenandoah's Song" that the Indians brought provisions of deer,

squirrel, roots and berries, but Braddock eventually ordered them away because he did not like the lifestyle of the Indians. The Iroquois, on the other hand, respected Washington and called him Purposeful Young Man. The Iroquois sang songs to ensure Washington and his men's survival in battle, and though Braddock was ambushed, wounded and left to die a few days later, Washington emerged unscathed, though his clothing was torn by four balls and two horses died beneath him. The Iroquois believed Washington would go far.

Before the French and Indian War, Skenandoah was sent south to confer with the Cherokee, who are related to the tribes of the confederacy, and speak an Iroquoian language. Skenandoah's mission was to speak to them about the difficulties arising between the French and English. Skenadoah, also known as Shenadoah to the Mohawk, came at last to a valley of breathtaking beauty cut by a wide stream. He traveled that way until he found some hunters who led him south. As they parted, Skenadoah signed to them, asking them what they called the beautiful valley, and they told him it was the Shenandoah Valley. Skenandoah laughed and explained that some people call him Skenandoah and some Shenandoah. He thanked them for naming the valley after him.

At last Skenandoah found the Cherokee, and spoke to them about the colonists and of the French and English. There he learned that the Cherokee had had a teaching relationship with both Thomas Jefferson and his father. They had finally left him because Thomas Jefferson had too many responsibilities to continue their conversations.

According to "Skenadoah's Song," at the time of the Continental Congress, three Mohawks were sent as representatives as well as a member of the Turtle Clan of the Oneidas, and Skenandoah was the Wolf Clan representative from the Oneidas. However, at the Congress, the Indians were denied access to hear the discussions, so they offered a formal presentation instead. This presentation is recorded in the fifth volume of the *Journals of the Continental Congress 1774–1789* (the presentation is dated June 11, 1776). This presentation was a short overture of friendship between the Indians and the colonists. They also offered some gifts and gave John Hancock the name Karanduawn, or Great Tree, representing the Iroquois Tree of Peace, and which also represents the Iroquois Confederacy. It is likely the Iroquois saw the new Union as similar to their own confederacy and wished to honor the president of the Congress by this name.

Though the Indians were denied access to hear discussion in the Congress, they did not leave, but sought Franklin in the evenings after others, such as Jefferson and Adams, had left his company. However, soon Franklin grew

An image of the Continental Congress entitled, "Washington, appointed Commander in Chief." Iroquois were said to have listened outside at the windows during sessions of the Continental Congress. Published by Currier & Ives circa 1876, New York. *Courtesy of the Library of Congress Prints and Photographs Division.*

weary of attending the conference all day, and meeting with others all night. He needed rest. Instead, he began to complain loudly at the conference that the heat was stifling to him and that he needed fresh air. The window would be thrown open, and parts of the Indian delegation would clandestinely gather beneath the open window to listen. Often, they say, Franklin would sleep during parts of the Congress, leaving instructions to delegates on when and how to awaken him so that he might not miss pertinent parts of the debates.

One day, though, during an important debate, it began to rain, and the window was quickly closed by Franklin, who pointed to the open door. The guard denied the Indians access until Franklin prodded him to allow them to enter for shelter during the storm; at last, some in the Congress complained of the smell (apparently the scent of drying deerskin was rather pungent), and the Indians were asked to leave. At that point, the Mohawks left, offended by the colonists. However, the two Oneidas remained, hoping to see the resolution of the issue of whether slavery would be allowed within the new nation. In the end, Franklin found it could not be resolved, and decided that to compromise on the issue was a better solution than to risk the failure of the formation of the new union.

Skenandoah's Boulder. This boulder lies on Route 5 in Oneida Castle near Skenandoah's old home. *Courtesy of the author.*

At this point, it is said Skenandoah prophesized that there would be a great internal war because of this issue in a hundred years—a war that would exceed all others in bloodshed and at last, then, all men would be free. Skenandoah left, never to see Franklin again. The great Skenandoah, the mighty warrior, wept for three days.

A boulder commemorating Skenandoah's home has been placed on Route 5 near Oneida Castle. The inscription reads:

> *THIS MARKS THE SITE OF THE LAST HOME OF SKENANDOAH, CHIEF OF THE ONEIDAS; "THE WHITE MAN'S FRIEND." HERE HE ENTERTAINED GOVERNOR DeWITT CLINTON 1810 AND MANY OTHER DISTINGUISHED GUESTS AND HERE HE DIED IN 1816 AGED 110. HE WAS CARRIED ON THE SHOULDERS OF HIS FAITHFUL INDIANS TO HIS BURIAL IN THE CEMETARY OF HAMILTON COLLEGE, NY AND LAID TO REST BESIDE HIS BELOVED FRIEND AND TEACHER REV. SAMUEL KIRKLAND.*

> *"I AM AN AGED HEMLOCK. THE WIND OF A HUNDRED WINTERS HAVE WHISTLED THROUGH MY BRANCHES: I AM DEAD AT THE TOP. THE GENERATION TO WHICH I BELONGED HAVE RUN AWAY AND LEFT ME."*

> *SKENANDOAH*

POLLY COOPER AT VALLEY FORGE

History tells us that through the influence of his close friend, the Reverend Samuel Kirkland, Skenandoah was convinced to support the cause of the American Revolution by offering the services of 250 Oneida warriors, who served primarily as scouts and messengers. One of the most striking gifts of aid came during the icy winter in which Washington's troops suffered because of extreme cold and hunger at Valley Forge. During that winter, Oneida men and women walked four hundred miles to Valley Forge, Pennsylvania, carrying six hundred bushels of corn loaded into pack baskets for the starving troops. It is said that the troops were so famished that they would have eaten the corn raw, but the Oneida women cooked the corn so the troops would not become ill from them. The Oneidas stayed until the troops fared better, and then left with only Polly Cooper remaining, who stayed on to cook for the troops. The Revolutionary forces survived to defeat the British.

Martha Washington took Polly Cooper to Philadelphia and bought her a shawl and bonnet in gratitude for her aid and the gift of her time. Though the bonnet no longer exists, or has vanished with time, the Polly Cooper shawl is venerated by the Oneidas and is occasionally displayed behind glass at their cultural center. It is owned by a descendant of Polly Cooper.

A TRANSATLANTIC LOVE STORY

The Mohawk Valley was known as Tyron County around the time of the Revolution. Since then it has been divided into multiple counties. Roughly one third of the 308 battles fought during the Revolutionary War were fought in New York State, and the majority of those battles occurred in Tyron County. Central New York was at that time the frontier. Indian attacks on settlements were frequent. Though much of the farmland in Central New York is devoted to the dairy industry today, at that time much of the land was used to grow wheat. The British understood that this wheat was vital for feeding the Continental army and so Tryon County was under constant siege from British forces and their Indian allies. The torching of barns was a common British practice. It is believed that around 1777, the white population of the Mohawk Valley was about ten thousand; however,

by the end of the war, only approximately three thousand remained, such was the devastation. Of those that fled, approximately three thousand were believed to be Loyalists, and a similar number were Patriots. Another thousand were either killed or captured. Some Patriots that remained in the valley fled their farms for the increased security of forts. By the war's end, it was found that upward of twelve hundred farms had been left fallow.

The region was tremendously polarized politically. Though an individual or family may not have been radically in support of either side, choices were forced. Tyron County's Committee of Safety between 1776 and 1777 determined who were Patriots and who were Loyalists. Loyalists (or Tories) regularly suffered severe consequences. This was the volatile atmosphere that existed in Central New York during the time of the Revolution; however, all of this must have seemed a world away when Charles Ross, a young military man, fell deeply in love with a young woman named Frances in London. Frances was promised to an older man in marriage, and her family had already planned the wedding. When Captain Ross's regiment was to sail to Canada to be stationed on the New York frontier, the two clandestinely met before he departed, vowing eternal love. Should he not return, Frances would find Captain Ross abroad.

As the dreaded wedding date drew near, Frances began to plan her escape, purchasing men's clothing for herself and cutting her beautiful brown hair. She disguised herself as a young man and sailed across the sea in search of her love. She called her new self Frank Reade and sailed away on a merchant vessel, having purchased passage for port in Quebec. Frank was the ship's sole passenger, and soon she found herself overcome with sea sickness and under the care of the kindly captain's wife. It was not long before the captain's wife discovered that Frank was not a man at all, and Frances confided her sad tale of love to her.

When they finally reached port, the captain accompanied "Frank" to the commandant of the citadel to discover where Captain Ross's regiment was located. The news was not good. The regiment was in Montreal, but had suffered great casualties through battle and illness. However, upon arriving in Montreal, Frank found that Captain Ross had been moved to Oswego, under a Major Ross and Lieutenant Walter N. Butler. He was assigned to raid villages located in the Mohawk Valley, specifically Johnstown. Furthermore, the detachment had left Montreal several days prior to Frank's arrival. He hoped to follow if he could find a proper guide.

Frank located a Mohawk Indian named Onatassa, who advised a route through Lake Champlain. And so Onatassa and Frances, dressed in the

buckskin of a woodsman, embarked on their journey, traveling by birch bark canoe. Frank became tanned and boyish-looking and developed physical strength along the journey. They paddled for two weeks, traveling out the Richelieu River from Lake Champlain to Lake George. There they abandoned the canoe in the woods to travel on foot sixty miles to Johnstown, their destination. They traveled with even greater caution now that they might be found by Continental forces. At last, toward the end of October, they drew near their destination and camped by a stream. Here Onatassa confronted her, asking whether the Captain Ross she sought was her lover or her brother. He told her he had known that she was a woman for some time now. Flustered by his sharp observation, she asked why he had not told her that he knew. Onatassa explained that he did not speak because she wished her secret remain hidden.

One morning Onatassa did not return until the sun was high in the sky. He reported that there was a battle at Johnstown between the American forces under the command of Colonel Willett and the British, commanded by Major Ross. The British seemed to be prevailing so the two hastily packed and hurried to the battlefield, concealing themselves in a nearby gorge.

Initially, the American forces were pushed back and retreated to St. John's Church in the village, but once they received reinforcements, they advanced and attacked the British, driving them back into the woods towards East Canada Creek. Captain Ross, maintaining the rear guard, was struck in the chest with an arrow and fell unconscious into the thicket. The army continued its retreat. Lieutenant Butler was killed during the retreat by an Oneida Indian, but the army at last found their way to Oswego.

Onatassa reported what he knew to Frances, relating that Captain Ross had vanished between Garoga Creek and West Canada Creek. This journey was six hours from where Frances was hidden; however, nothing would keep Frances from her love. Abandoning most of her possessions, she told Onatassa to lead while there was still light, and the two of them journeyed, arriving at Garoga Creek just before dawn. Onatassa spied something ahead, and raised his rifle. They stood face to face with a large grey wolf. Onatassa fired, killing the wolf, but soon they heard a moan arise from the thicket nearby. They searched through the underbrush, sweeping away the vegetation, and there lay the wounded Captain Ross. Frances knelt beside him and pressed her cheek to his, and Onatassa prepared a litter, using two saplings and the blanket, to carry the captain out of the bush.

Infantry of the Continental army. Much of the Revolutionary War was fought in Central New York, which was then frontier and farmland. Henry Alexander Ogden. Lithograph by G.H. Buek & Company, New York. *Courtesy of the Library of Congress Prints and Photographs Division.*

Tearing open the captain's shirt, Francis discovered an arrow wound. Onatassa brought him water, and Frances gave him a sip of brandy. With this, his heart rate seemed to increase, giving Frances renewed hope. She was a surgeon's daughter, and had often accompanied her father when he performed surgical procedures. She had purchased a small surgeon's kit when in Montreal, and now she drew it out to remove the imbedded arrow head from the chest of her lover. Onatassa removed the arrow as Frances prepared to bathe the wound in brandy and sew it closed.

Onatassa inspected the arrow and pronounced it poisoned. Without hesitation, Frances pressed her mouth to his gaping wound and sucked out the poisoned blood. She then poured brandy on it and closed the wound. Captain Ross seemed to improve with the doctoring, but had not regained consciousness so they removed the captain to Onatassa's father's vacant house, which was nearby.

After a week, the captain came to regain consciousness under Frank's attentive care. Onatassa provided them with food from his hunting excursions, and provisions from nearby Johnstown. With the captain conscious, Onatassa explained that he must return to Canada soon, but Frank implored him to remain two more days while he traveled to Johnstown on business. While the captain had been unconscious, she had gone to Johnstown and ordered ladies' undergarments to be made but was unable to procure a proper dress. Instead, she purchased, using money from the gold concealed in her belt, the embroidered buckskin skirt of a Mohawk woman. She was able to purchase a belted silk blouse with a bit of lace interest around the neck and sleeves. Next she headed to the home of Reverend John Urquhart of St. John's Church, telling her story to him and asking if he would marry them the very next day. She arranged for rooms for the two of them.

After returning, she greeted her lover and escaped behind a blanket curtain to change into her feminine garb, equipped with dark hose and riding boots. So dressed, she revealed herself to Captain Ross with the words, "Charlie, love!" Captain Ross was stunned. "Sweetheart!" he cried, taking her into his arms. She told the story of her long search for him, the tale of her three-thousand-mile journey through unknown wilderness and enemy territory.

The reverend soon arrived to give the sacred vows to the joyous couple. Onatassa served as best man, and the landlord's daughter, with whom Frances had arranged for a cottage abandoned by a fleeing Tory family, served as a witness.

When Onatassa left to return to Canada, Frances offered him her gratitude and multiple gold coins. He left her with these words: "The paleface maiden is happy today. May sunshine always brighten her life. The memory of her bright eyes will illuminate the path of Onatassa in his journey through the forests." And with that, he left.

The couple enjoyed four happy years together, but Frances had swallowed the poison from Captain Ross's arrow, and her health slowly left her. They say Captain Ross later died of a broken heart. Frances returned to England, where her family forgave her. Frances Ross died at age twenty-six.

Part III

The Erie Canal

Stories of Red McCarthy

The Erie Canal was one of the most ambitious and controversial public works projects undertaken up to that time. Along this route, stories abounded, and the canallers often favored exaggerated tales of imaginary heroes such as Red McCarthy, the strongest man on the canal. Red McCarthy was a mule driver for a canal boat. On the canal, the team and the hoggie, otherwise known as the mule driver, were switched every six hours. The boat would stop and lay down a plank known as a horse bridge. The old team would be retired, and then a fresh team would be brought down the bridge to the tow path, and traveling would resume. One day, however, Red realized how much time they were wasting stopping the boat and placing the plank down. Clever as he was strong, McCarthy devised a way to save time. He trained the mules to walk tightrope style across the towline so he could avoid placing the plank to switch teams.

One day, soon after McCarthy began his six-hour stint, the towline broke. Not to be stopped, McCarthy picked up the line, slinging it over his shoulders, and towed the boat himself. Strong as he was, McCarthy failed to realize that the boat, which was hauling a heavy load of crushed stone at the time, was slowly filling with water and sinking. He hauled for five hours before noticing what had happened, unwittingly dredging the canal. The state legislature was so pleased with his work, with McCarthy having deepened the canal by four feet for a full seven miles, that they voted to pay him $500 for his hard labor.

A view on the Mohawk River. Illustration in *New York Magazine*, 1793. Engraving by Cornelius Tiebout. *Courtesy of the Library of Congress Rare Book and Special Collections Division.*

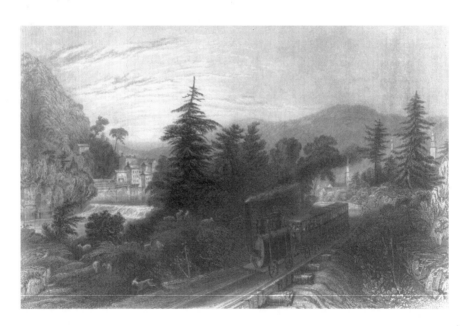

Little Falls became a lock site on the Erie Canal. *Railroad Scene, Little Falls.* Steel engraving by R. Sands after drawing by W.H. Bartlett. *Courtesy of the Library of Congress and Photographs Division.*

Boats passing through the Erie Canal were once pulled by mules that were piloted by mule drivers, or "hoggies." *Courtesy of the author.*

Canal boat in downtown Syracuse located next to Erie Boulevard. *Courtesy of the author.*

Now Red McCarthy was a man who worked hard, and partied hard. He loved to dance. One day, as he was making a haul, he heard rumor that a dance hall had burned down, and all the young people in that community had been preparing for their big dance event. The whole thing was going to be cancelled. Red wouldn't hear of it. He loaded his boat with stone and hauled it at a goodly speed all the way to the site of the burnt-down dance hall. Then he flipped his boat over and they used it as a dance floor. It was smooth as silk, and that night was a real dance to remember.

THE EMPEYVILLE FROG

One day while on South James Street in Rome near the canal, Red McCarthy spotted a pollywog and he named it Joshua. He kept the darling creature until one day it grew legs and hopped away, disappearing for some time until it at last surfaced in Empeyville Pond nearby. My how Joshua had grown! When fully developed, he measured a full six feet long in the hind legs and about three in the front. By then he was feeding on the especially large insects of the area as well as on a variety of smaller animals such as squirrels and rabbits and such. So great was Joshua's size that when he leaped into the pond, the water spouted over thirty feet high, and the pond dimensions enlarged by at least six feet due to flooding from the jump.

Now Joshua, like his owner Red McCarthy, was a hardworking sort, always ready to lend a hand. It wasn't long before he was hired as assistant saw man at Empeyville. And a handy employee he was indeed! When the logs were too massive for a team of horses to contend with, Joshua would pull the load. However, his fame was more for his public works than for his long hauling. The roads around the area were in terrible shape. They zigzagged and curved around so no one could drive them with ease. That is where Joshua came in. A stout chain was fastened around Joshua's waist on one side, and by a hook to the road on the other. Then, Joshua would give it his best jump, and in the mere blink of an eye, that road was straightened and lengthened! That must be why we have so many superior roads around here. Joshua is also credited with moving the town barn thirty-three and a half feet. You might think that was a bit much for a mere frog, but truly it was only child's play for Joshua and I assure you he wasn't the least bit sore after the fact.

Floyd Esch sighted Joshua back in the summer of 1934, and it was reprinted in the *Rome Sentinel*. It reads as follows:

> *I had been north of Empeyville building a picnic table for a Roman business man at his camp and this Roman will vouch for the following event. As we were returning home late one evening and arrived at the Busy Corner in Empeyville, Old Joshua sat under a tree catching for his supper some of the monstrous insects that inhabit the region. We waited nearly half an hour for him to get his fill. While we were waiting, the pond filled with water. As Joshua turned and entered the pond, the pond overflowed and washed the road out so that we had to rebuild it before we could proceed home.*

It is a fact that four of Joshua's grandsons are used by the city as stump pullers. They are owned by a Roman although they do not approach Joshua's incredible size or musculature.

Ronald J. Deeley lived some time in the Empeyville Pond vicinity. In fact, for many years, he occupied the home of Colonel Richard Empeyville, built back in 1844, and Ron's father and grandfather both helped dig the Erie Canal. One day when Ron returned home from a trip from Texas, Reverend Raymond Linza asked him what his next adventure would be. Without hesitation, Ron Deeley replied that he hoped to single-handedly and humanely capture Joshua, the famed Empeyville Frog. Ron had a plan (or, shall we say, a variety of plans). Ultimately, however, he hoped to capture the giant frog without injury to either party, and to place it in an enormous geodesic dome covering the several acres of land that he had. The dome would be a giant petting zoo and the admission would be free. Instead, the whole affair would be paid for by concession stand sales and many large animal feed machines charging twenty-five cents a handful. There could also be 8"x10" glossies sold of visitors petting or standing near the giant frog at a price of fifteen dollars apiece. Most of his money, however, would be made when the frog was taken across country on tour. On the road, Ron planned to charge at least a dollar and a half admission.

Why do it? Well, he explained, the population of New York State has fallen tremendously since 1972, when there were twenty-four million people living in this state. Now, Ron says, there are less than nineteen million. Ron served as president of the chamber of commerce between 1980 and 1982 and realized the need for an attraction that would draw crowds to the area. What could be more exciting than the Empeyville Frog?

Now catching the frog might not be terribly easy. For starters, Ron calculated the size of the frog at its last sighting in the '30s and its rate of growth. Now he estimates that Joshua weighs approximately four thousand pounds and has an unfurled tongue two hundred feet long. Capturing the beast unharmed and single-handedly could be a problem.

Various methodologies were considered, such as Ron dressing himself as a giant mosquito and dangling from a rope attached to a plane to lead the frog to the dome. However, this could only be accomplished with great care, or Ron could conceivably become frog fodder. Another approach would be to cut the ice around the frog into a floating island and float the frog the few miles downstream to Ron's property. That, of course, could only be accomplished at the proper time of year. A third possibility would be to have a product manufactured similar to "Doggie No" (used to keep dogs away) but with a scent repulsive to frogs, called "Froggie No." Ron aimed to scent either side of the trail with "Froggie No" to keep the frog in the trail and lead him right to the dome. He had even contemplated making a giant trap similar to a humane animal trap, but the cost of the size of trap needed proved prohibitive.

I asked Ron if he had ever sighted Joshua in all those years, and he said many times. Griffiss Air Force Base radar was routinely used to locate the frog—he was pretty sizable anyhow. No, it wasn't a lack of sightings that kept Ron from his plan; rather, when he saw and tackled the frog, he just never seemed to have the right equipment handy. Ron sought Joshua for many years, but eventually sold his home and moved to Watertown. I asked him if he still hoped to capture Joshua, but Ron says he is sixty now and can't tackle the frog like he used to. The move was a change for Ron. His family had lived in the Camden area for some time. He tells me his grandmother was a great cook and his mother followed in her footsteps. She even opened a restaurant and she would bring the Glenmore Dam workers her marvelous sandwiches. He sandwiches were known to be the best sandwiches by a dam site. Ron explained to me that Glenmore Dam is but a hop, skip and a jump from Empeyville Pond and that Joshua often was seen lounging around Glenmore Dam.

The Empeyville Frog continues to be honored by local people in the Camden area. Lawrence Kent has written a musical about the frog called *The Big E*, which has been performed at occasional festivals held in honor of the immense frog.

Snow Dye

Ron Deeley was really one of the area's foremost entrepreneurs. Not only did he hope to enrich our region by capturing the frog and bringing commerce to the area, but he had hopes of exploiting our area's greatest natural resource—snow—using the famed Lake Ontario Snow Machine. Of course the Camden region is located on the Tug Hill Plateau, notorious for excessive snowfall. Ron wanted to harness that. He is looking for venture capital to begin research and development into the process of capturing the snow and extracting the white dye from it. Imagine the myriad uses for white dye—think about how clean you could make everything look! I think the world is ready for Central New York's new export. If you would like to support Ron in his latest plan, just give him a call. As for myself, I can't wait to go to his first white sale. This could be big!

The Dry Canal

It's hard to imagine that water would ever be in short supply in this land of snow and rain, but keeping the canals filled has always been an issue and remains so even today. In fact, last fall, the cities of New Hartford, Utica and many others in the water district were only days away from an empty drinking water supply when the dam on Hinkley Reservoir was left open to keep the canal levels up for boaters.

Apparently, water supply was historically an issue as well. One year, it was exceptionally dry, and though the canal system was specially constructed with dams and reservoirs to feed the thirsty canal, it still went dry. It was so dry that simply filling a washtub in the canal could strand a dozen boats, and sharpshooters were hired to take down the occasional bird that landed to sip from the parched canal. Weeds and vines were carefully removed from the towpath, as who knows how much water those root systems might be sucking from what precious little that was left in the canal? The water was heavily guarded that year, but farmers were suffering the most. It became common practice, once night fell, to dig up your plants, and tippy-toe down to the canal to dunk their parched roots into the precious water under cover of darkness. Once they were sated, the farmers would sneak back, and replant their crops.

There was a Utica farmer who had the scrawniest squash plant you had ever seen. The man had been nursing it along for weeks using his own spit and at last, the miserable plant had developed just a few of the

tiniest buds upon it. He knew the time had come when this plant needed a bit more than some used saliva, and so one night, he dug that squash plant up, and spirited it away to the canal. He slowly lowered its roots into the water, and man, that squash was thirsty! It sucked the canal dry, just as easily if it had been a pump, leaving three miles of bare soil in either direction. Water was all that vine had been lacking, and as soon as it had it, it took off. The vines shot out in either directions, and the buds became flowers in the blink of an eye. The flowers withered and squash pumped up like balloons. The vines started shooting out as if fired from a gun. and the farmer, filled with fear, ran for his life. He reached out toward the vine and caught hold of that ballooning squash. It sucked water down so quickly it exploded, sounding like a shot fired from a gun. I suppose it felt like a shot fired from a gun, too, because that farmer's hand had been right over the squash and was blown right off. It's a sad tale, to be sure, but the farmer did all right by it. He collected all those bits of hardened squash shell and sold them for a tidy profit as drainage tile.

SIG SAUTELLE, THE CIRCUS MAN

One can hardly think of this region without recalling the tales of Sig Sautelle, who made his name bringing wholesome entertainment to all at a reasonable price. In fact, Sautelle's circus was thought to be so clean it was called "the Sunday School Circus" by some, and its price never rose above twenty-five cents during its half-century of operation; children's admission was a dime. Sautelle ran a circus transported on canal boats, later on wagons, then rail road cars and finally motorized trucks. While the circus itself, filled with amazing acts and wild and weird beasts, was fascinating to be sure, Sig Sautelle was perhaps more so.

Sig Sautelle was born George C. Satterlee in Luzerne, New York, near Glen Falls, perhaps in 1848. He prided himself on being the youngest voluntarily enlisted soldier in the Union army during the Civil War, joining at the youthful age of fourteen, and Satterlee often told of his service in the Eighteenth New York Volunteer Infantry. It is said that he joined out of an extraordinary sense of patriotism and adventure, and stories tell us that he even distinguished himself in battle. During the war, while he served as a drummer boy, he met a ventriloquist and magician and paid to learn these skills by doing chores for the man such as blacking his boots, repairing

Sig Sautelle's Circus. *Courtesy of the Cortland Historical Society.*

his uniform and washing his clothing. Interestingly, however, the name "George Satterlee" appears nowhere in the muster rolls for the Eighteenth New York Volunteer Infantry. One could not serve in the infantry without being on the muster rolls, which were used to issue equipment and pay to the soldiers, nor can one be discharged from the infantry without having been listed. There is a "George Satterlee" listed on the rolls of 104th New York Volunteer Infantry. Though Satterlee claims to have been discharged at the end of the Civil War, it would have been difficult for a fourteen-year-old boy to pass as a man at so young an age. An alternative theory may be that Satterlee was with the army as a servant, and may have been paid by an officer, who allowed him also to act as a drummer boy. This seems more likely when the tasks that Satterlee performed are considered. Nonetheless, Satterlee learned the art of magic, showmanship and throwing his voice, and these skills would serve him over a lifetime in the field of entertainment—and in courtship.

Satterlee returned home following the close of the Civil War and began working as a printer's devil, and then in a wagon wright's shop. He practiced these trades in Saratoga, Glen Falls and at Fort Edward. Both

these professions would help prepare him for his future path. It was there at Fort Edward that he became captivated by Ida Belle Travers. He impressed her with magic and ventriloquism, and she, in return, encouraged him to become a showman. And so it was, with Ida's prompting him to perform, in his twenty-forth year, Satterlee bought a wagon for six dollars and a blind horse for thirteen, and invested another four dollars in a harness. Satterlee studied the repertoire of Punch and Judy and then presented it with his own twist in his traveling show. After Satterlee married Travers, they traveled together in his wagon. The two were always a team throughout their marriage—she ran the financial aspect of the show, and he designed and managed the show itself. Satterlee never tired of his beloved Ida, and idolized her until her death and beyond. Her illness and eventual death would bring ruin to the great showman, who could not find inspiration or hope without his love.

Satterlee's first show was small in scale, and was performed here and there in halls and other community locations. He moved his suitcase show from place to place quickly, jumping around to bring his show wherever he could, and so the people began to call him "sauterelle" or "grasshopper" in French. Satterlee liked the term, and shortened it a bit to become his stage name, Sautelle. He added the first name "Signor," but Satterlee was blue-eyed and hardly appeared the Latin type, and so the second syllable was soon dropped in practice. Another version of how Satterlee became Sig Sautelle is that he fancied himself a magnificent Italian circus performer and so he is immortalized as the great Sig Sautelle. As they traveled, they added some vaudeville characters and animal acts. Roads were poor back then, and sometimes not labeled at all. There is one story of a prankster switching the road signs and scattering bushels of potatoes on the road. The elephants, unable to leave a tasty morsel unsampled, stood there in the road until each and every potato was eaten before they would move on. This provided immense amusement and entertainment for the boys of the area, who had gathered by the road to watch the detour. The circus at last moved on, but not toward their correct destination. This event seems much more likely to have occurred during Sautelle's wagon circus days, perhaps in the late 1880s (not 1860s as claimed), but it does highlight the road conditions of the time. It is believed that Sautelle would eventually form a canal circus to avoid the poor roads that were prevalent.

Soon Sautelle came to the attention of Stowe's Great American Circus, where he became a sideshow performer. Later, he joined with Barnum and Bailey, but by 1882 he had opened Sautelle's Parlor of Fun and Dog Circus. Two years later, he traveled with the Gregory Brothers Show, again

as a sideshow performer. Here, Sautelle experienced something that would forever alter his future—he was bitten by a dog. From that day forward, Sautelle grew to loathe dogs.

By the following year, Sig had broken away to create Sig Sautelle's Big Shows. This show was, in fact, a first in circus history, for he intended to transport his circus by canal boat, traveling the Erie, Chemung, Chaplain and Seneca Canals on two boats—one for the performers, named the *Belle* after Ida Belle, his wife; and one for the animals, wagons and other paraphernalia needed for his circus. The second boat was named the *Kitty*. I am uncertain whether the *Kitty* was named after a person or commemorating the cat band Sautelle had at several times. This cat band consisted of several cats to which invisible strings were attached, who were operated like marionettes and beat drums. In a later version of the show, Sautelle added wind instruments. During the winter, Sautelle lived on the *Belle* and ran his dog circus for the locals.

Sautelle's canal circus traveled this circuit for five years, working the waterways in season. During the winter months, Sautelle allowed the canal boats to freeze in the ice of the canals in Syracuse and kept them open as lager saloons, hiring out his horses to Syracuse for city labor. Sautelle was said to have used his wagon-making mastery during this period. He created low wagons that, when set on a canal boat, would still be able to pass beneath the deadly low bridges of the canal system. Later, when Sautelle left the canal route, he sold the *Kitty* to a missionary group who renamed the boat the *Good News*. The *Good News* gained notoriety when, one day not long after it's purchase, as it was docked in downtown Syracuse, it caught fire, burning and sinking. Fortunately, most of the crew was not aboard. Surely, the boat's fate was anything but good news.

This seems a perfect spot to relate the story of the circus fire, a story with a radically different outcome than that of the *Good News*. In the year 1899, Sautelle's Circus was at St. Regis Falls when lightning struck in the nearby woods. Soon a forest fire began to rage. The woods were dry, and the heat grew great. The performers and animals as well could hear the loud cracking as the fire drew closer and the animal keepers were forced to double chain the animals to prevent a stampede. Soon a sense of fear and doom began to consume the crew and cast as the fire surrounded them. All the performers knelt to pray, with the obvious exception of the animal keepers. The flames had come to within twenty rods of the circus tents when, miraculously, the wind changed and rain poured forth out of the sky, leaving the circus untouched.

As time passed, the areas along the canal became more developed, and better roads appeared, prompting Sautelle to once again turn to his wagon-making past and create a wagon circus. The wagon circus would allow Sautelle to explore communities farther inland and to expand his performance season. Furthermore, the size of Sautelle's circus had grown too great to travel effectively by canal. Sautelle innovatively used wider wheels to gain traction on soft ground and introduced a new kind of wheel lubricant to withstand the high temperatures that might be encountered during summer traveling. Sautelle supervised the building of the wagons, and sturdy they were. In 1932, it was known that a canvas wagon made in 1887 for the Sautelle circus was still in use in a farm not far from Fort Edwards.

Though Sautelle had used Syracuse as his winter headquarters in prior years, the building had been sold and Sautelle was forced to find new quarters for his circus. Soon, he settled on DeRuyter, where he purchased what became known as Hotel Sautelle. He also purchased a four-hundred-acre farm with barns. However, wintering in DeRuyter was not the panacea that Sautelle had hoped for, and he was soon driven out—because of a dog. One day, a wagon was being unloaded and a case of eggs was being carried into the cook tent, when a dog of extraordinary size appeared suddenly and jumped on the worker carrying the flat of eggs. The eggs went everywhere, and many were broken and oozing; nonetheless, the good ones were salvaged and at final count it was determined if each person only ate one egg, there would be enough to serve. Sautelle refused to let the dog go unpunished and ran after the beast that, in return, bit Sautelle, reaffirming his growing hatred of canines. Sautelle returned in a miserable mood, and was informed of the egg status. It was said he stood in the mess tent, holding up a single finger while hollering to the cook "Give them all the eggs they want!"

Dogs continued to plague Sautelle. He went so far as to ban dogs on the grounds. There was a dog in DeRuyter that was known or thought to be ferocious and was obviously large. Sautelle sought out the owner of the dog to offer to purchase the animal so he might either destroy it or send it away. The owner, not impressed by performers in the least, began plaguing Sautelle, walking his dog past him if he could predict Sautelle's whereabouts. He would take his dog down to the railroad depot if he knew Sautelle's circus train was coming to town, and at last Sautelle fled, this time establishing his winter headquarters in Homer, New York, where, as far as we know, he remained relatively dog-free.

Sautelle sold Hotel Sautelle and purchased a new hotel to house his performers in Homer, which he called the David Harum House. Sautelle

loved the circus, and so his architecture began to reflect his circus life. In time, he built three tent-shaped structures in Homer—an eight-sided animal barn, training stables and a ring barn. All three were a bright circus red, and though planked with wood, they gave the appearance of being made of red brick. At present, only one of these buildings still exists and is pictured in this book—the Octagon House (or the Circus House, as it is known to some), built in 1902 and located at 161 Main Street in Homer, New York. The house started as animal quarters, and then human habitation was added above. It currently is occupied by a lighting and antique shop. Originally, there was an interesting structure that jutted out of the south side of the building over the entrance to the basement. This covered the entrance, where animals were brought into the basement using ropes and pulleys for winter quartering.

I have been inside this building, and the current owner showed me the rooms upstairs where the performers were housed. The performers lived on the second floor and the animals below in the basement. There, the owner told me, they could practice their acts during the off season.

People say something was always happening around the circus. Elephants grazed on the grass, people were occasionally mauled by the wild animals that belonged to the circus and then there was Sig himself. It was easy to tell how lucky Sautelle was feeling. He wore a horse pin made of diamonds on his lapel when he felt lucky, and did not wear it when he did not. Sautelle favored diamonds and became known as the Diamond King. He wore an assortment of diamond rings on his hands, and before the circus would perform, he could be seen lounging in the sun allowing its light to sparkle in his diamond jewelry. When showtime came, he promptly would rise and stow his mattress.

Sautelle was known to fly in the face of superstition and he always chose to open his show on the Friday as close to the thirteenth of May as possible, much to the chagrin of his more cautious employees. Friday the Thirteenth notwithstanding, success seemed to come to Sautelle and his circus. He was always full of innovation, and, it seemed, ever expanding.

As the railroads became established as the premiere form of transportation, Sautelle adapted, taking his circus by rail in 1902. He used two sixty-foot-long railroad cars to transport his show, which by then consisted of fourteen cages of animals and four elephants, as well as abundant performers. Travel by train meant the circus could travel longer distances to play in more densely populated locations. Sautelle's circus fame expanded as the size of his circus expanded. The circus would strike while the tents were still full and the audience fully engaged. They moved with speed and efficiency so

Sig Sautelle's octagonal home in Homer, also known as the Circus House. Today the home is a lighting and antique shop, but originally there was a structure on the south side of the home where animals would be lowered via pulleys into the basement. The circus members would winter here with Sautelle and his wife Ida, rehearsing in the basement area. The shape of his home was inspired by that of a circus tent. *Courtesy of the author.*

when the final show ended, the circus vanished in short order, and they were speeding off to their next venue.

In the first decade and a bit beyond the twentieth century, Sautelle participated in a few circus partnerships. In 1914, he drew few crowds. People had little money, and there was the war. People were not seeking out entertainment, and certainly not paying for it. Entertainment enterprises everywhere were closing. He tried to move on to new towns, but things did not improve, and at last Sautelle was forced to sell his beloved circus at a pittance. Sig was not the only one affected by this sad situation. Ida, wounded by the loss, suffered a nervous breakdown, and the two of them traveled to Florida while she took time to heal herself. When the two of them returned home, Sig began selling his properties, and became a poultry farmer, but the great showman was not meant to lead a life of plowing up grubs for the white leghorns. Sautelle created a tent show of *Uncle Tom's Cabin*, but audiences remained small. Ida died at last in 1916. Ida had been such an important part of his life, Sig must have felt he had lost a great part of himself that day, and he was really never the same. Still, in 1917, he

Sig Sautelle's circus tent. *Courtesy of the Cortland Historical Society.*

started a small circus with Oscar Lowande and started one of the first truck circuses. But early in April, war was declared on Germany, and with young men disappearing into the military, the customer base was reduced. People simply weren't attending.

With his wife's passing and his show's failure, Sig was no longer the man he once was. He retired to Glen Falls, near the home of his youth. Other show people came there too. There, near where he began, Sig started a Punch and Judy show called "the Humpty Dumpty Circus," which played in local venues such as schools and halls. He also resurrected his cat orchestra to the delight of his audience. He remained a showman to the end. Sig Sautelle was honored in the Circus Hall of Fame in Sarasota, Florida. He was an originator and a showman beyond compare.

A WHALE OF A TALE

On an annual basis, bikers converge on the Seneca Falls area, are offered the region's bounty of wine and cheese and told this story by Francis Caraccilo and Doris Wolf. The story begins one of two ways, depending on the source. If one believes the poster of the event, then a whale was

DON'T FAIL TO SEE THE
LARGEST WHALE
Ever Captured on the American Coast.

WILL BE ON EXHIBITION
On the Canal by Gleason's Knitting Mill, near Ovid St. Bridge,
In Seneca Falls, Monday & Tuesday, Nov. 10 & 11.

THIS MAMMOTH WHALE was captured by Capt. Nickerson, June 5th, 1888, off Cape Cod, 15 miles from shore, 100 miles from Boston, shot with a boom lance, weighed 75 tons, and was 65 feet long. It took 1,500 gallons of fluid to embalm this huge amount of flesh, at a cost of $3,000. You must consider the monstrous size of this animal, when his Tongue Weighed 3,500 Pounds and made 120 Gallons of Oil. His Lower Jaw will seat 25 persons. His Mouth has been fitted up as a Reception Room. A person six feet tall can stand erect in his Mouth, between the Monster's Jaws. We have had 25 young ladies and their teacher in his Mouth, all at the same time; also seen 12 gentlemen seated in his Mouth, enjoying an oyster supper. His Whaleship has been on Exhibition over Two Years, in the Principal Cities of Seven States, and Viewed by Hundreds of Thousands of Astonished People. It is not only a Wonderful Sight, but instructive to Men, Women and Children. The Captain and his Aides will instruct you of the Different Species; how they are captured; show you the Ancient and Modern Weapons used to capture them. Go and see for yourself, and if you find this is not a real Whale, we will cheerfully refund your money.

On Exhibition from 9 A. M. Until 10 P. M. Daily.
ADMISSION, - 15c. CHIDLREN, - 10c.

A poster of the whale that was transported up the canal as a tourist attraction; paying customers dined inside the whale's semipreserved mouth. *Courtesy of the Seneca Falls Historical Society.*

killed by a whaler in Cape Cod, Massachusetts, on June 5, 1888. If one listens to the word of others, the same whale was killed in New York Harbor in a collision with a boat in 1888. One thing is clear, however, a sixty-five-foot, seventy-five-ton whale died in 1888, and the party responsible for it declined to sell the beast for whale oil. Instead, they embarked on a remarkable scheme to make big money using its carcass as an exhibition hall.

The decision to embalm the whale and take it on tour came with a large price tag. The whale was hoisted onto a barge and $3,000 was required to purchase the 5,000 gallons of embalming fluid needed to preserve the whale. To mitigate the costs of embalming, the whale's 3,500-pound tongue was removed and sold to make 120 gallons of whale oil. Once embalmed, the remodeling began. The molar jaw was converted into a comfortable reception room that could seat twenty-five and accommodate a six-foot-tall man wearing a hat as he stood in a fully upright position. At one point, it is told that twenty-five young ladies and their teacher had tea inside the whale's mouth. At another time, a party of approximately twelve men dined on an oyster supper there.

The price of admission for this extraordinary dining hall was set at fifteen cents for an adult, and ten cents for a child, and it was guaranteed fully refundable if you could prove it wasn't a real whale. Apparently, no one attempted to prove its falsehood, as over the life of the exhibition, not a single cent was refunded.

Initially, the tour proceeded along the Atlantic Coast, hitting all the prominent cities, and it proved popular, and we presume profitable. When two years had passed and the whale had been exhibited up and down the coast, the owners decided to move on to new territory. They decided to take the whale up the Hudson and into the canal system, where there would be an abundant inland audience who had never viewed a whale. The problem was that the whale had been embalmed fully two years before, and by then, it was beginning to become a bit ripe as the embalming fluid had slowly worn off. This necessitated treating the entire whale with a few gallons of "volatile liquid" at each and every port of call. As they moved inland, the most accessible volatile liquid was frequently whiskey.

It was late in the season, perhaps in November of 1894, when the pickled whale docked in Seneca Falls. Though fully past its freshest moments, the whale was an undeniable hit, drawing huge crowds. Train traffic made the area accessible to even those not able to travel along the canal. It is said that people dined on tea and crumpets inside the mouth of the rapidly deteriorating whale. It was such a magnificent success that the operators

decided to travel up the Cayuga Seneca Canal to Waterloo, and there they docked. Something happened there, though what it was is not perfectly clear. Some say that hooligans set fire to the whiskey soaked carcass causing damage. Others say vandals threw a stick of dynamite into the mouth of the whale, causing an explosion which blew deteriorating whale blubber across the streets of Waterloo. Still, the owners were not daunted. They decided the up-and-coming city of Rochester would be their next port of call, and headed up the canal for that purpose. Reports of the whale's imminent arrival created a stink with Rochester Health Department officials, and they banned the whale from traveling on the Cayuga Seneca Canal. However, the owners were intent on showing their whale to the awaiting Rochester audiences, so they backed the whale down the Erie and through part of the Oswego into Lake Ontario, determined to arrive at their destination. But the weather changed quickly, as it does in these parts, and a great storm arose. The barge capsized, and the whale sank. Apparently, it remains there to this very day, a whale at the bottom of Lake Ontario.

Part IV

RELIGIOUS MOVEMENTS AND UTOPIA

A MIRACLE IN PALMYRA

After barely surviving 1816 (the "Year without a Summer") in Norwich, Vermont, Lucy and Joseph Smith arrived in Palmyra with little more than nine cents in their pockets to start a new life for themselves and their family. They had originally been landholders and shopkeepers, but Joseph had been cheated of his money on a substantial crop of ginseng by a shipping captain who later, while drunk, confessed to the crime and fled. The family had lost their property, and later fought an epidemic of typhoid, in which their son Joseph almost lost his leg and spent several years recovering. Mrs. Smith, running out of money a few miles west of Utica, was nearly robbed of her wagon and team of horses by Howard, an unethical man who had traveled with them and who had previously forced the lame Joseph to limp along in the snow after the wagon so Howard could make room for some girls in the Smiths' wagon. When Joseph's brothers protested, they were struck with the handle of the whip by Howard.

Many Vermonters moved to New York State after the "Year without a Summer." Land was advertised for sale around Palmyra for two to three dollars an acre, and the Smiths felt they needed a new financial beginning, so they headed west. There was also a promise of future prosperity with the plans for the Erie Canal that would pass near there. The Smiths worked doing what they could, and eventually made arrangements to purchase some wooded land on which they built a very snug and cozy home, as Mrs. Smith would describe it. It was very small for their large family. The log home was then in Farmington, which was later called Manchester. It was described as

having two rooms downstairs and a low garret divided in two parts above. Ten people occupied this house. For this farm of one hundred acres, they were to pay $100 annually. This was a great struggle for them, as money was scarce in the region, and as they grew, the sons were put to work on the farm, or working for neighbors. Lucy made and sold cakes wherever people gathered. They cleared the land and planted crops. Too poor to send their children to school, the children were educated at home. Young Joseph was not drawn to reading or book learning and was considered quite ignorant by some of the town folks, though he was considered a hard worker by some who hired him.

Family religious life was split. Lucy, Hyrum, Sophronia and Samuel joined the Western Presbyterian Church in Palmyra, but Joseph Sr. and the rest, including young Joseph, joined no church at all. Joseph Sr., though unaffiliated with any organized religious group, participated in reading the Bible with the other members of the family and frequently had visions that were spiritual dreams. He often spoke of these visions to his wife and his family. Young Joseph was troubled by the religious division in his family, but also by the religious rivalry of the local churches. The area was ripe with both revivals and competing ideas of what was true in a religious sense. Joseph believed, even at an early age, that the revivals that were sweeping the countryside were creating divisions rather than unifying people. He sought to know which church was the real church and how he could be saved.

Seeking an answer, young Joseph fled the crowded cabin to a secluded spot in the woods to seek God's advice on these matters. In 1820, he prayed for the help of God, and a shaft of light fell upon him and he was filled with the spirit of God. He saw the Lord, who offered Joseph forgiveness for his sins and told Joseph to keep God's commandments. When Joseph asked which sect was right, he was told he should join none of them, that all of them were wrong and an abomination to God. Later, Joseph revealed this to a Methodist minister and was stunned when the minister treated his vision with serious contempt.

On the evening of September 21 in 1823, young Joseph was engaged in praying devoutly to God when a mysterious light appeared in the room, growing and growing in its brilliance until it soon shone as strongly as the light of a bright noon sun. An apparition appeared alongside Smith's bed. The specter was a man wearing brilliant white robes unmatched to any that Smith had ever laid eyes upon, and though he had feet and legs, the apparition stood not on the ground, but hovered in the air above it. His whole person shone and the room was greatly illuminated, but the

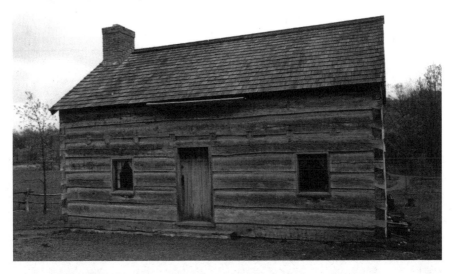

Joseph Smith's reconstructed wooden home, where he and his family first lived in the Manchester area. *Courtesy of the author.*

brightest light shone near the apparition itself. Though Smith first felt fear upon seeing this vision, the fear rapidly left him.

Then the brilliantly glowing man spoke, calling Smith by name, and told him his own name was Moroni, and that God had a special work for Smith to complete. Moroni then told him that there was a book written on golden plates that recorded the former inhabitants of the continent, their history and origin. The book also told of the Gospel as told by Jesus to the people of the continent.

In addition to the marvelous book, there were two stones in silver bows that, when fastened to a breastplate, functioned as the Urim and Thumin. These objects were hidden with the plates and when in the possession of one and used, would constitute Seers. These objects would be used to translate the book as ordered by God.

Though the time to obtain these objects was yet to come, Moroni explained that Smith may only show these great things to those he would be commanded to show them to by God. If he did otherwise, he would be destroyed. As Moroni spoke, another vision appeared, showing Smith the secret place where these sacred objects were hidden. Later, Smith would recognize this place when he went there. Then the light receded until the room was darkened as was natural for that time of evening, and Smith saw a great conduit open up into heaven and Moroni ascended.

The sacred grove where Joseph Smith witnessed a holy vision. *Courtesy of the author.*

As Smith lay pondering this mysterious vision, the light began to brighten once more. Soon the messenger appeared again and repeated the same message as before, without deviation. However, after he had done so, he added that great judgments were coming to earth this generation and there would be famine, sword and pestilence. Once again Moroni ascended into the heavens above.

By now, Smith sat wide-eyed and astonished in bed when, once again, Moroni appeared amidst the light and repeated the exact same message as before, but now adding that Smith would be tempted by Satan to use the gold plates for profit, because of his father's family's poverty. Moroni forbade this, telling Smith that he must have no other purpose than to bring glory to God and build his kingdom. If his purposes were otherwise, Smith would not obtain the tablets. Moroni took to the heavens once more, leaving Smith with his thoughts. Soon after, the cock crowed and day broke. Smith realized that the visitations had occupied the entire the night.

Smith began his day of farm labors, working beside his father, but he soon found he had no energy. His father noticed his troubles and told him to go home. Smith started toward the house, but did not make it past the fence when his strength vanished leaving him collapsed and unconscious.

At last a voice spoke to him, and called his name. Again the messenger surrounded by a great aura of light floated above the ground nearby. The

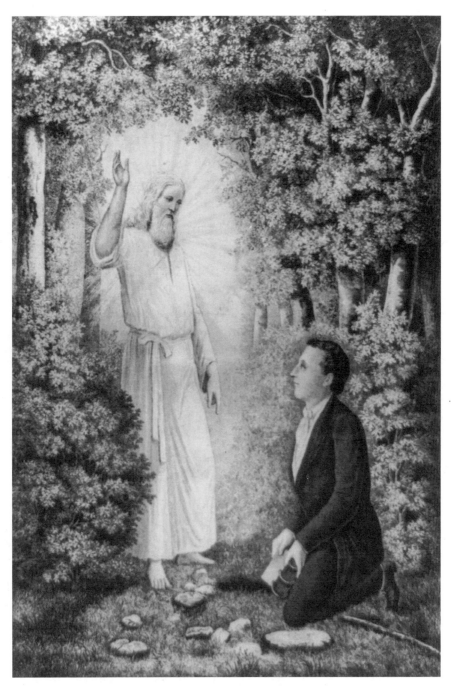

The angel Moroni delivering the plates of the Book of Mormon to Joseph Smith Jr. Published circa 1886. PGA-Bording. *Courtesy of the Library of Congress Prints and Photographs Division.*

This monument of the prophet Moroni stands on Hill Cumorah, where the golden tablets that Joseph Smith translated were found. No one knows the exact location on the hill where the tablets were exhumed. The statue overlooks a mowed section of the drumlin where a great pageant is held each July by the Church of Latter Day Saints at which parts of stories from the Book of Mormon are recreated. *Courtesy of the author.*

message of the night before was repeated once again, and this time Moroni added that Smith should relate the message to his father. Smith did this, and his father, upon hearing the wondrous message, told his son that truly it was God's message and that he should do as the messenger commanded him.

Smith sought out the place he had seen the previous night in his vision, the place where the golden plates were buried. He immediately recognized it when he laid eyes on it—the vision had been so clear in his mind. Near the village of Manchester where Smith lived was a drumlin. On the west side of the hill close to the top, beneath a sizable stone, were the golden plates inside a stone box. The stone was partially buried, but Smith removed the earth surrounding it and used a lever to raise the stone and saw that the plates, Urum and Thummin, and the breastplate were indeed beneath it. All of this lay inside a box made of stones set in a cement-like substance.

Smith made to remove these objects, but the heavenly messenger forbade it, explaining that the time to remove these objects was yet to come. In fact, these things would not be removed for four more years, Moroni said. Smith should meet him again in a year at this very place. Each year on that date, Smith and Moroni met there, but the objects were not removed.

Finally, on September 22 in 1827, the objects were to be excavated and removed from their hiding place beneath the stone. Moroni explained that Smith must be responsible for them, and not treat them carelessly. They must be protected until Moroni came for the sacred objects.

It soon became apparent to Smith why he was ordered to protect the plates and other objects, because as soon as their nature became public knowledge, people tried everything to obtain the golden plates. But God and Smith protected them until Smith's task was accomplished and the messenger Moroni called for them on May 2 in 1838. The document that was recorded in the form of the golden plates was translated into modern speech by divine means using the devices Smith was given and by the seeing stone, and published in 1830 as the Book of Mormon.

The Smith family continued to struggle to make their annual payment on the farm, and their working-age sons were often hired out to work for neighbors, usually performing farm-related chores. However, young Joseph had other skills as well. He had developed a reputation as one who could see things that others could not. It was said he was in possession of certain keys that enabled him to see what was invisible to others. Joseph had a peep stone—that is, a stone into which he could look to find lost objects and know other things. This stone, as later described, was about the size of a hen's egg, though otherwise shaped, and predominantly dark, almost black in color with some lighter-colored stripes. Mr. Stowell, however, described the stone as white and transparent. The dark stone previously described was in 1888 consecrated upon the Manti Temple altar and was described in a Wilford Woodruff's journal as the stone that "Prophet Joseph Smith had found by revelation some thirty feet under the earth and carried by him through life."

In October of 1825, Joseph was approached by a man named Josiah Stowell, a farmer from South Bainbridge, to work for him as a money digger for the rate of fourteen dollars a month. "Money digger" was then the term used to describe what we now call a treasure hunter. Mr. Stowell had become convinced that he had discovered the approximate location of a lost Spanish mine from times gone by. He believed that ancient coins had been minted and buried at the spot in the Susquehanna Valley and wished to use Joseph's skill to locate the lost treasure. Reputedly, Mr. Stowell had a document in his possession that gave the location of the ancient mine. Both Joseph and his father went with Mr. Stowell to Harmony, Pennsylvania, and the group took up residence with the Hale family, whose home was located close to the believed site of the mine. The Hales had nine children, and one of them, Emma—a tall, dark-haired girl with hazel eyes who worked as a

school teacher—would later elope with Joseph against her family's wishes. Mr. Isaac Hale described Joseph's technique of using the peep stone as looking into his peep stone inside his hat while his face was buried in the hat. While Joseph is said to have described vast treasures at first, he later determined that there was nothing to be found and convinced the group to return home—an enchantment that was on the treasure caused it to disappear to Joseph as they approached it. At last, the group returned home after a month of unrewarding work, owing $12.68 to Mr. Hale; according to Mr. Hale, it was never paid.

There is some murky evidence that Joseph Smith faced misdemeanor charges of glass-looking in Judge Neely's court. Joseph Smith testified that he looked for the gold mines using his stone on behalf of Stowell, but gave it up because the practice made his eyes sore. One Jonathan Thompson testified that Joseph and a man called Yeomans went out to look for a chest of money using Joseph and his seer stone. Thompson believed in the stone, and they seemed to strike the chest, but it kept settling downward because of an enchantment on it.

In another reported account of the same trial by Dr. Purple from Bainbridge, who reputedly took notes at the trial at the judge's request, Joseph Smith testified that when he was young, he had met a girl who owned a glass. She let Joseph look through her glass, and after many years passed, he found a stone himself that allowed him to "annihilate distance, so gaining one of the attributes of deity." In this same version, there is testimony that the money-digging party attempted to break the enchantment on the treasure by fasting, praying and even sprinkling lamb's blood around the suspected treasure site to appease the spirit. However, none of these techniques led to the discovery of the ancient mine. Joseph Smith Sr. expressed disgust that such a miraculous gift should be used on such base enterprises as the search for wealth. In most accounts, but not all, young Joseph Smith is found guilty of misdemeanor glass-looking, but no sentence is recorded.

Joseph asked for Emma's hand in marriage, but was refused by Isaac Hale, who found Joseph to be uneducated, careless and insolent, not to mention a glass-looking money-digger. Worst of all, Joseph was not a Methodist. Nonetheless, Emma was not a child and could legally marry of her own accord and so on January 18, 1827, Joseph put Emma behind him on the back of an old horse, and the two of them rode off to be married. Emma brought no luggage or furniture. In time, an appeal was made to her parents for her things. Joseph returned to get her belongings several months later, and Mr. Hale suggested they return to Harmony, and it is said Joseph promised to give up glass-looking. Soon after his return home

to Manchester, however, Joseph encountered Moroni again, who scolded him for neglecting God's work. Moroni told Joseph that the time had come to retrieve the tablets.

The key to translating the golden plates was supposed to be the Urim and Thummin. Lucy Smith, Joseph's mother, described these as being two, smooth, three-cornered diamonds that were inset in glass. The two glass pieces were in turn affixed to silver bows and appeared similar to spectacles. Joseph was quite excited about the Urim and Thummin and explained to his family that he could see anything with them. With the Urim and Thummin came a breastplate. Lucy was not allowed to view the breastplate, but was able to feel it through the handkerchief Joseph had used to cloak it. It was of immense size, as if it had been made for a huge man, and it had straps with which to fasten it to a man's hips and shoulders. The breastplate itself was convex-concave and Lucy could see it glisten even beneath the muslin kerchief.

When Joseph brought the golden plates home, Joseph Sr. was surprised that his son would not show the plates to them. However, young Joseph assured him that he did not intend to disobey God's word again, and he was not to show them to anyone until they were translated, unless ordered by God himself. However, like the breastplate, Joseph let his family feel the golden plates beneath their fabric sheath. They appeared to be thin sheets of metal that could move like pages of a book, and they were heavy, perhaps weighing sixty pounds. The metal was thought to be a mixture of copper and gold. Joseph described the plates as "writein in caracters."

Soon the reason for the secrecy became apparent, for interested parties from all corners began poking about, hoping to catch a glimpse of Joseph's golden Bible. At one point, a group of armed men rushed into the Smith house, hoping to find the plates. However, Joseph had hidden them behind some loose stones in the hearth, having anticipated such a situation through his peep stone. The men of the Smith house rushed at the armed men and the invaders scattered.

One of their neighbors, Willard Chase, had fetched a conjurer from sixty miles away, and came to the property with ten men to search it. It was later learned that Sallie, Willard's sister, had led the search, resulting in the Smith's cooper shop floor being torn up and their property searched and ransacked. Sallie had a piece of green glass in which she was said to see marvelous things. Apparently, the green glass had at least some power, because at that point Smith had hid the chest in which he had kept the plates in the floor of the cooper shop. The plates, however, had been removed and hidden amidst the flax in the loft above. Though the searchers located the chest, they were unable to find the plates.

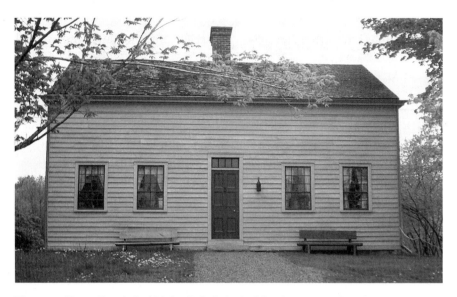

The second home Joseph Smith's family built in the Manchester area. It was larger and more commodious than the first, but they were unable to keep it for financial reasons. At one point, the golden tablets were hid beneath the removable bricks in front of the fireplace in this building. This house is the original structure. *Courtesy of the author.*

During this time, no translation was possible with the constant invasions and searches from nosy neighbors. At one point, Martin Harris, a successful farmer in the area, met Smith in town and offered him a bag of fifty silver dollars and suggested that Smith leave town and use the money for God's work in a safer place. Subsequently, Joseph hid the plates in a box at the bottom of a forty-gallon barrel of beans. He filled his wagon with other household needs and headed down to Harmony with his pregnant wife, Emma.

When they arrived, Emma's father, skeptical of the plates, described the box which held the plates as being approximately ten by twelve inches in size. He was furious that he was not allowed to see the contents of the box that was being brought into his home. Emma and Joseph moved into a small house on Emma's father's land. Joseph translated from December to February, but could not write well, so he used Emma as a scribe as well as her brother Reuben on occasion.

Emma said that Joseph began translating using the Urim and Thummin, but later used an almost-black stone to translate. He would sit for hours with his face in his hat, not reading from any manuscript, while she transcribed his words. Emma wrote that he could not have done this had he not been inspired because Joseph was so ignorant and unlearned.

The reconstructed cooper shed where Joseph Smith hid the golden tablets to keep them from the eyes of prying neighbors who searched the property with the aid of a mystical seeing device. *Courtesy of the author.*

Initially, Lucy (otherwise known as Dolly Harris), Martin's wife, had been excited and supportive of helping to provide funding for the translation efforts. However, as it soon became apparent that she would not be allowed to view the golden plates, she became increasingly skeptical and more and more certain that she and Martin were being duped. When she learned that Martin would be involved in the translation process, she began to put pressure on him to provide evidence that this was not an elaborate hoax. Dolly had previously offered money to view the plates and had been refused. Martin left to go to Harmony two months after Emma and Joseph had gone. About then, Oliver Cowdery had been told he could help with the translation as more than a scribe. To speed things along, Cowdery would be allowed to translate himself. However, he soon found that having possession of the seeing devices and the plates was little help, for he was unable to translate a

thing. Joseph told Cowdery after his lack of success that "you must study it out in your mind" and then ask God if it is indeed correct. With this advice, though, Cowdery found no success, and so the task of translation fell again solely to Joseph.

With his wife's assistance, Smith began making a copy of the symbols and translating a portion of them. Once Joseph had done a bit of translation, Martin Harris was supposed to take the papers to New York City to some learned men for their scholarly opinions. Harris went to New York with Joseph's brother Hyrum. Although Martin Harris apparently had a list of "learned men," only one was available and that was a man named Anthon, who taught Greek and Latin at Columbia College. Martin Harris went to Anthon alone and each tells a different tale of the event. According to Harris, Anthon told him the translation was correct, "more so than any he had before seen translated from the Egyptian." Regarding the untranslated characters, Anthon is believed to have said they were true "Egyptian, Chaldaic, Assyric and Arabic," and then Harris was handed a certification of that fact. When, however, Harris told him they were from golden plates uncovered under the direction of an angel, Anthon is said to have torn up the certificate, stating that no such thing was possible. He would translate the plates if they brought them to him. Later, Harris said he spoke to a Dr. Mitchell, who also verified the translation.

Anthon, however, described the incident quite differently in two letters. Anthon objected to the Mormon's using his name for their purposes. He said he was approached by a simple-minded farmer who brought with him a scroll containing characters in columns. The characters were a hodgepodge of alphabets, including Greek, Hebrew and Roman letters sideways or inverted, crosses and even a crude depiction of the Mexican calendar. He said "the paper contained anything else but 'Egyptian Hieroglyphics!'"

After Martin returned from New York City, he told his wife that he intended to help with the translation. Dolly insisted on accompanying him to Harmony, and henceforth proceeded to search the Smiths' home and searched the grounds surrounding it, as well, but to no avail. Smith had hidden the plates outside of the house. Dolly Harris soon became convinced that Joseph Smith intended to cheat them out of house and farm. When she returned to her home, she began to hide things so they could not be sold to support Smith's efforts.

In April of 1828, Martin returned to Harmony again to help Joseph translate. Joseph remained hidden behind a curtain with the plates so Martin could not view them. For most of the translation, Joseph was said to not have used the Urin and Thummin, but instead his seer stone. As when money

digging, he would place the stone in his hat, and pull it over his face. He used this technique during most of the translation. Martin, having his doubts, and facing questions from Dolly, found a stone by the river one day during one of their breaks. He took it back with him, and substituted the river stone for Joseph's. To his relief, Joseph exclaimed upon trying to use the stone substitute, "Martin! What is the matter? All is as dark as Egypt."

Still, Martin was wary. He pressured Joseph that there be other witnesses of the transcript. He hoped to bring a copy to show his wife to assuage her fears. Initially, Joseph inquired of God and received a negative answer. However, pressed further, he asked again. At last, Martin would be allowed to take some of the pages, but he must only show them to his wife, mother, father, wife's sister Abigale Cobb and his brother Preserved. Martin left with the manuscript. At last, Joseph returned to his family home. In the morning, Martin was to come to breakfast at 8:00 a.m. He at last arrived at 12:30 p.m., moving slowly and behaving oddly. He seated himself at the table and cried aloud, "Oh, I have lost my soul! I have lost my soul!" The manuscript was gone.

Martin had shown the manuscript to his wife and she seemed much pleased. They locked it in her bureau drawer and would retrieve it to show the people that Joseph had named to be witnesses. However, one day, Martin had wanted to show it to a friend and found himself unable to find the key to the drawer, so he forced the lock. After that, he willingly showed the manuscript to anyone who came along. Dolly was angered that Martin had damaged her bureau. Martin moved the manuscript to a new place, but once the Smiths had returned from Harmony, the manuscript had vanished. Joseph, upon hearing the manuscript was gone, insisted that Martin search further for it, but Martin told him it would yield nothing as he had torn apart the whole house, ripping open pillows and the bed in the process. There was nowhere left to look.

When Joseph returned to Harmony, he prayed and received a revelation that he was not to retranslate the missing portion of the text because the manuscript was in the hands of evil men under the direction of Satan—men who wished to discredit him. The same material would be covered in the portion by Nephi.

Martin believed he should financially support the publication of the plate's translation, but facing opposition from Dolly, asked that there be witnesses to the plates. Joseph Smith prayed on the matter and it was revealed to him that there should be three witnesses to the plates. In June of 1829, Oliver Cowdery and David Whitmer were to witness the plates. Martin Harris was told he would also bear witness to the existence of the golden plates if he were granted forgiveness for his various sins.

Following the morning scripture reading at the Whitmer place, Smith, Harris, Cowdery and Whitmer walked off into the woods and sat on a log to pray—Joseph praying first, and then each of the rest, but to no avail. They continued praying until Martin Harris rose and told the others that he was certain they could not achieve results because of his presence, and so he walked off, leaving the other three to continue their prayers. Suddenly a light shone from above, surrounding the men and beyond. An angel appeared, robed in white, and spoke the words: "Blessed is he that keepeth His commandments." A table with the tablets appeared before them and God's voice spoke out, telling them that the book and the translations were true.

After the vision ceased, Joseph raced off to find Martin to tell him of the experience. Martin asked Joseph to pray with him, and he did until Martin exclaimed that he had beheld it with his own eyes. The witnesses signed a paper testifying that they knew the plates had been translated "by the gift and power of God," as declared to them by God.

Not long after this witnessing, Joseph allowed another eight people to view the tablets. This occurred in Manchester and the witnesses were Joseph's father, his brothers Hyrum and Samuel, four Whitmers (Jacob, Christian, John and Peter) and Hiram Page, a relative of the Whitmers by marriage. This time, however, Joseph himself showed them the tablets in a location in the woods where family members often retreated from their tiny dwelling to pray in private. The witnesses were allowed to handle the tablets, which had the appearance of gold and were covered with tiny engravings they believed to be of ancient origin. These witnesses also signed a statement that they had witnessed the tablets.

In March of 1830, Smith located a suitable publisher, Egbert B. Grandin, who published the *Wayne Sentinel* in Palmyra. However, Grandin required that Smith pay the sum of $3,000 beforehand. Martin Harris had agreed to finance the publication of the Book of Mormon. However, he had second thoughts about it. He tried to obtain a loan for a bit under half the amount, but was refused when the lender learned what he was funding. At last, Martin Harris mortgaged his farm to Grandin under the understanding that if he were to default, Grandin could take the farm. The money was to be paid within eighteen months to Grandin. At last the presses began to roll in August of 1829.

However, negative publicity soon began to appear in print in the surrounding area. Smith ordered the entire manuscript be copied by hand so the original would not go to the printers and only a day's worth of copy was sent at a time as a safety precaution. Nonetheless, the text was leaking

out to the press, and one Sunday Hyrum caught Abner Cole in the Grandin Print shop, printing notices in the *Reflector* that he would be printing bits of the Book of Mormon in the *Reflector* in advance so people would not need to purchase the Book of Mormon. Though he was stopped, sentiment against the Book of Mormon in the local community was growing and people in great numbers were pledging not to buy it. This alarmed the publisher, who now insisted they pay in full or he would not continue to print.

Harris was under great pressure from his wife not to pay it. He asked Smith for a revelation. Smith prayed and heard the following:

> *I command you to repent-repent, lest I smite you by the rod of my mouth, and by my wrath, and by my anger; and your sufferings be sore—how sore you know not, how exquisite you know not.*
>
> *And again, I command thee that thou shalt not covet thine own property, but impart it freely to the printing of the Book of Mormon, which contains the truth and the word of God.*
>
> *Impart a portion of thy property, yea, even part of thy lands, and all save the support of thy family.*

Martin sold part of his farm to pay the printer and the first five thousand copies were printed.

Martin's wife did indeed leave him and neighbors began to talk. Martin Harris later remarried a Mormon woman and had a family with her, but she left and migrated west to Utah with the children, leaving him as they followed Brigham Young. Martin left the church, but moved to Utah himself decades later to rejoin them and reaffirmed his faith.

The Book of Mormon gives the accounts of two ancient peoples as told by Mormon, who abridged earlier texts. The first group was the Jaredites, who came to the New World after the fall of the Tower of Babel. Another people migrated to the New World from Jerusalem in the year 600 BC. Subsequently, they became divided into the Nephrites and the Lamanites. Many thousands of years ensued and at last the Jaredites and the Nephites vanished. It is said that only the Lamanites remained and that the American Indians sprung from those people.

One of the most vital elements contained in the Book of Mormon is Christ's post-resurrection ministering to the Nephite people. Through this, they were taught the gospel and the path to salvation, as well as how to find peace on earth and eternal salvation.

When Mormon finished his abridgment of the work of these ancient prophets, he passed the plates to his son Moroni who, after adding a bit

himself, hid the works on Hill Cumorah beneath the great rock. Later, it was this same Moroni, in a glorified and resurrected form, that would appear to Smith to instruct him on translating and locating the lost golden plates.

The Oneida Community

The Mansion House served as a residence hall for the Oneida Community, a nineteenth-century utopian community started by John Humphries Noyes. The community was one of the most economically successful utopian communities of its time, it is believed, because they later based their livelihood not on agriculture but on other forms of industry, such as trapping, the silk thread trade and later silver. Their silver business withstood the breakup of the community and they became Oneida Limited, thriving as a silverware producer until only a few years ago. Community and employee devotion was high and the company withstood a takeover bid by Libby, only a few years later to decline, closing their American manufacturing production facilities.

The Oneida Community was a religious group headed by Noyes, and known as Perfectionists. They believed in Bible Communism, which encompassed the idea of community property and complex marriage. The group practiced stirpiculture, a type of selective breeding designed to create a better generation of offspring. Some of these beliefs and practices excited the imagination of outsiders, and many stories were told of the Oneida Community, which the community, in turn, recorded in their circular for their humorous value.

Insiders, too, had their stories. One of the most important ones may be of Noyes, himself. Before the Oneida Community was created, when Noyes spoke in Putney, Vermont, he exclaimed that the Kingdom of Heaven had come. At this declaration, there was a sudden peal of thunder, though the day was clear. This was taken as a direct sign of approval by God himself.

When I first arrived here in Central New York, my neighbor told me that in the Sherrill-Kenwood area, I might find the people were exceptionally tall. This was due to the stirpiculture experiments of the Oneida Community. Along with trying to breed a more spiritual people, they also attempted to breed tall people, believing that tall people were more likely to be spiritual. In fact, he said, if you look at the ceilings in the Mansion House, you will notice how exceptionally high they are. They needed to accommodate the very large people who lived there.

Group on the east lawn of the Oneida Community Mansion House. *Courtesy of the collection of the Oneida Community Mansion House, Oneida, New York.*

It was well known to the outside world that the Oneida Community believed in complex marriage. All the community members were married to each other. Stories were told that in the main hall was a gigantic round bed, where the community members would go to take their pleasure.

This is the tale of a person identified only as "L." One day L was feeling ill, and since L's room was located in a rather noisy section, a friend offered the use of her room. L thanked her and went there forthright to get some needed rest, but found the room cold. "I wish I had a shawl," L thought, and as soon as it was desired, he noticed a blanket shawl folded on the nearby ottoman. The shawl then levitated and slowly floated to the bed as if carried by unseen hands. There it was deposited neatly for the comfort of the recuperating L.

Initially, the community was socially isolated, when it survived on a solely agricultural basis. However, as they expanded to other trades, they gained more contact with the outside world, and even encouraged tourism of their utopian community. Nonetheless, outsiders were often suspicious of them and their ways, and harbored strange notions about the community and its members. One of these beliefs was that there was a dungeon somewhere in the basement of the Mansion House where disobedient members were held. Perhaps this belief continues today in some respect. Kate Moss, former curator of the Mansion House, was asked by a young girl if there was a room in the basement where a crazy man was kept. Apparently, there was a closet on the lower level where paint and other such mundane items were stored, that had a "Keep Out" sign on the door that sparked the imagination of the girl.

The Mansion House is open even today for tours and as a residence hall. It is located in the community of Kenwood in Oneida, New York, just outside of Sherrill. An original bedroom, a small museum, the auditorium and other elements are featured in the tour.

Part V

ABOLITIONISTS, UNDERGROUND RAILROAD CONDUCTORS AND SUFFRAGISTS

THE SCYTHE TREE

Located at 841 Waterloo-Geneva Road on Routes 5 and 20, two miles west of Waterloo, stands a 150-year-old balm of Gilead tree, a type of poplar. A small parking area is provided at the farm for those who wish to stop to view the legendary tree, known as the Scythe Tree. Its story began in the fall of 1861. The Civil War had begun and recruiting meetings were beginning to be seen in the area. James Wyman Johnson, a farm boy, had attended such a meeting that day, but though he felt the call of his patriotic duty, he knew equally well that he was needed at the family farm. That evening, as James mowed with his scythe, he made his decision. He would leave and enlist in the Union army to serve his country. James returned to the house to tell his parents, who were saddened by his decision. Then he took his scythe and carefully placed it in the crotch of the still-young tree near the farmhouse. He told his parents to leave it there until he returned, and James enlisted in Company G of the Eighty-fifth New York Volunteers. He was twenty-six years old.

James did return for a short while on furlough in 1863, but the scythe remained where it had been. His condition had much deteriorated, his parents noted. James returned to the war and was taken prisoner in New Bern, North Carolina, then later released. Johnson was promoted to sergeant, but in 1864 he received a wound in the upper thigh in Plymouth, North Carolina, from a carbine blast. Johnson understood this to be a death sentence and gave his money to a friend to pass it on to his parents. However, his friend, Lieutenant Pierson, was forced to march to Andersonville and

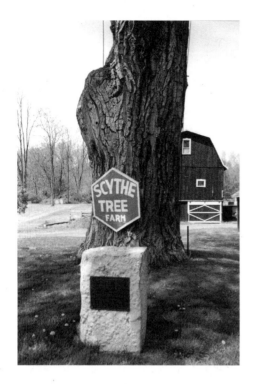

The Scythe Tree, located at the Scythe Tree Farm in Waterloo. *Courtesy of the author.*

Close-up of the Scythe Tree. The tree contains three scythe blades, but only the tips can be seen. The rest were engulfed by the tree over the years. The tips and surrounding areas have been painted to make them more apparent on the massive tree. *Courtesy of the author.*

the money may not have arrived to Johnson's family. Johnson died at the Confederate Hospital in Raleigh, North Carolina, on May 22, 1864, never to retrieve his scythe.

News traveled slowly and when it arrived in Waterloo, Johnson's parents either could not, or chose not, to believe that their son was dead and so the scythe remained lodged in the crotch of the tree, and the tree slowly consumed it.

Toward the beginning of World War I, two brothers living on what had by then become known as the Scythe Tree Farm decided to enlist in the United States armed forces. The first brother, Raymond Schaffer, joined Company F, Thirty-third Engineers on January 18, 1918. On March 22, 1918, he placed his scythe in the tree and the Carpenter's Local Union No. 187 hung an American flag over his scythe. On May 28, 1918, Lynn Schaffer enlisted in the U.S. Navy. Likewise, he hung his scythe in the tree the following day and the Young Men's Bible Class of the First Presbyterian Church of Waterloo kept a flag over his scythe. James Wyman Johnson also had a flag maintained over his scythe.

The Schaffer boys returned home alive and their flags were removed. To symbolize their return, they removed the wooden handles from their scythes but allowed the metal blades to remain in the tree.

Today, the tips of the three scythe blades can still be seen protruding from the tree. They project not much more than an inch or so, and have been painted so visitors are more apt to locate them. The tree is not in exceptional health, and it is expected that either it will die at some point or will eventually cover the three scythes completely with growth. The Scythe Tree is listed on the State Historic Tree Registry by the State Environmental Conservation Department.

The Jerry Rescue

One of the most defining moments in Syracuse's antislavery history was the Jerry Rescue. The Syracuse area was known to be highly opposed to slavery. In 1850, the Fugitive Slave Law passed, legislation that provided harsh penalties against those aiding escaped slaves and that allowed slaves who escaped north to be legally returned to their owners in slave states. The people of Syracuse were collectively outraged. On October 4, the mayor of Syracuse chaired a meeting of five hundred citizens who then formed a biracial Vigilance Committee, with each member pledging his life, honor

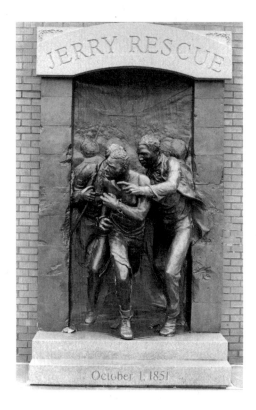

The Jerry Rescue is now immortalized by this statue that is located in Clinton Square in downtown Syracuse. *Courtesy of the author.*

and fortune to ensure that no slave would be returned who had reached the city of Syracuse. One man who addressed this crowd was Jermain Wesley Loguen, an elder of the AME Zion Church. Samuel J. May, a Unitarian minister for whom present-day May Memorial Church is named, also addressed the crowd and preached.

The very next day, Daniel Webster arrived in Syracuse, addressing the city from a balcony near city hall. He declared it treason to oppose the Fugitive Slave Law and promised that the law would be enforced, even during the antislavery convention.

At midday on October 1, local police and federal marshals from Rochester, Auburn, Syracuse and Canadaigua arrested a man known as "Jerry," whose actual name was William Henry and who worked as a cooper in Syracuse. "Jerry" was told he was being arrested for theft, but as soon as he was manacled, he was informed he was being arrested under the Fugitive Slave Law. Then "Jerry" began to resist. His warrant stated he owed "service and labor" to his owner in Missouri. This conveniently occurred as the Liberty Party of the State of New York was holding its convention in Syracuse at a nearby church. Reportedly, Commissioner Sabine's wife leaked the

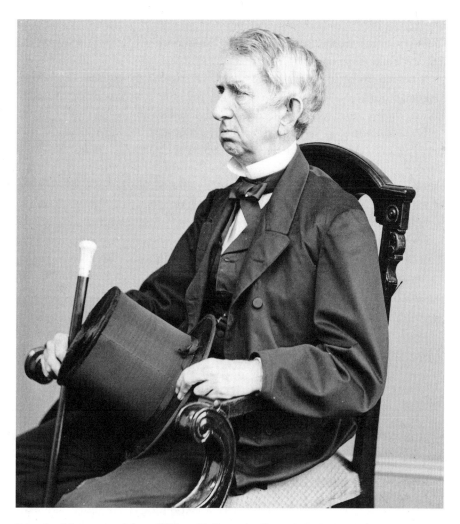

Portrait of Secretary of State William H. Seward, officer of the United States government. Part of Selected Civil War Photographs, 1861–1865. *Courtesy of the Library of Congress Prints and Photographs Division.*

information about "Jerry's" arrest, and when news of the actual arrest arrived at the convention, church bells began ringing across the city signaling people to come. They amassed outside of Sabine's office and tried to free "Jerry." Though "Jerry" made it outside, he was soon recaptured by authorities. The arraignment of "Jerry" was postponed until evening came. By then a mob of twenty-five hundred abolitionists had gathered. A battering ram was used to gain entry, and though shots were fired, "Jerry" was freed and hidden in a sympathetic butcher's home for several days before being taken to Oswego by wagon. Then he sailed across Lake Ontario to freedom in Canada.

Gerrit Smith introduced a resolution condemning Daniel Webster at the Liberty Party Convention.

Nineteen were indicted, though not Gerrit Smith or Reverend May. Loguen however, a fugitive slave himself, was. Senator Seward of Auburn, known for his antislavery sentiments, posted bail for the jailed.

The courts moved slowly, with the entire process taking two years, and only one person being convicted in the incident, and he died before he could appeal.

Gerrit Smith, determined to test the legality of the Fugitive Slave Law, filed charges against Marshal Allen for the kidnapping of "Jerry." Though he was indicted, Marshal Allen eventually received an acquittal.

For a number of years, Gerrit Smith led a commemoration of the Jerry Rescue on its anniversary, and a variety of abolitionist speakers were heard. In more recent history, a memorial to the Jerry Rescue was erected in Clinton Square facing the location of the jailhouse where "Jerry" was imprisoned.

HARRIET TUBMAN

Harriet Tubman is esteemed as one of the most daring and successful Underground Railroad conductors, credited with having made thirteen trips to the South to bring slaves to the North to freedom. It is believed that she led approximately seventy slaves to freedom directly and aided in the freeing of numerous others. She served as a spy in the Civil War, leading an assault on a number of plantations along the Combahee River, resulting in the freeing of over seven hundred people. Abolitionist Frederick Douglass said of this famed Underground Railroad conductor: "She never lost a passenger." Indeed, Harriet Tubman seemed invincible, using her sharp wit, sheer defiance and perseverance to see herself and her passengers to safety. She became known by the nickname of "Moses."

Harriet Tubman was born as Araminta Ross about 1820. She was uncertain of her own birth year, as was common among slaves. Later, Araminta, or "Minty" as she was called, took her mother's name of Harriet. Ross was born into slavery in Maryland, and began working at the young age of five or six in the house as a servant girl. One day, an angry overseer went after a field hand. Ross tried to block the doorway to protect the slave, but the overseer threw a two-pound weight at him, hitting Ross instead and cracking her skull. She received no medical aid for her head injury, and was returned bloody to the field to work two days

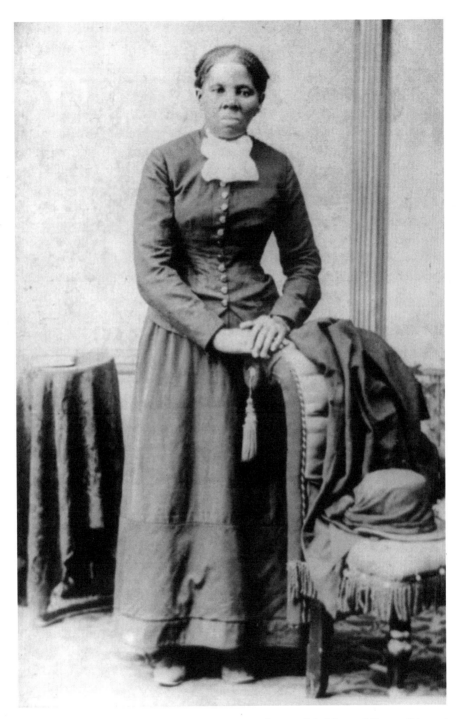

Underground Railroad conductor Harriet Tubman. *Courtesy of the Library of Congress Prints and Photographs Division.*

later. However, ever after she would have seizures in which she would spontaneously fall asleep. Often she would receive dreams and visions that she believed were from God.

Perhaps it was true that she had God's ear. When Tubman fell ill, her owner, a cruel man, tried to sell her. Each night she would pray to God to change his heart, and each day the prayer went unanswered. Finally she altered her prayer to: "Oh Lord, if you ain't never going to change that man's heart, kill him, Lord, and take him out of the way." At last God responded, and her owner Brodess died a week later. Tubman later felt remorse for her violent prayer.

Ross married a free black man named John Tubman. Disturbed at the prospect of being sold, she fled north on foot, traveling in the direction of the North Star and at last arriving to freedom in Philadelphia. Not satisfied to have saved only herself from servitude, Tubman returned to free her sister and sister's offspring. Later she returned again to rescue her brother and some others. Once again she returned, this time to bring back her husband. Tubman found that he had already wed again and was disinclined to leave. Instead she found new slaves to free. Each time using her razor-sharp wit, she passed invisibly across the ever-dangerous route north. The route was longer and more hazardous than when she had first escaped to Pennsylvania, for the year after her escape, the Fugitive Slave Law had made it necessary for slaves to be secreted, not just to the Northern states, but all the way to Canada to obtain safety and freedom. Tubman famously employed a pistol that she would put to the head of wavering escaping slaves, speaking the words, "You'll be free or die." Perhaps it was this iron determination—and Tubman's clear intellect—that kept them all safe. She was a master of disguise and a mastermind of escape. Tubman planned slave escapes late on Saturdays so the notices could not be printed before Monday, allowing them time to place distance between themselves and the plantation. When patrols would pass, she would silence the cries of the children by medicating them with paregoric so the fugitives would remain undetected. At one point, Tubman returned to rescue her aging parents from bondage.

Tubman served in a variety of capacities during the Civil War. She served as a nurse in Port Royal, using her knowledge of plants to heal the sick. She treated men with smallpox while remaining uninfected herself and people began to believe that Harriet Tubman was, indeed, blessed by God. Tubman served as a scout, mapmaker and spy, collecting valuable intelligence for the Union army. But perhaps her most dramatic work was her role in the Combahee River Raid.

On June 2, 1863, three steamships navigated though mined waters led by Tubman. Troops set fire to the plantations, and the steamboats sounded their whistles, a prearranged signal for the slaves to leave their plantations and run for the ships. Upon hearing the signal, a stampede of more than seven hundred rushed the ships, leaving landholders helpless in the mayhem as the steamships sailed away.

Tubman often recruited freed slaves to join the Union forces, and many joined because of Tubman specifically.

Tubman purchased a parcel of land in 1859 from Senator William Seward for $1,200, and brought her aging parents back from Canada to live with her, where she could care for them properly. After the war ended, Tubman lived in poverty, unable to draw a pension as a black woman who had served in a semiofficial capacity. She cared for her parents and others who needed assistance, and took in boarders to raise money. Several locals wrote letters of recommendations for her including Mrs. General A. Baird in Peterboro, New York, on November 1864, and abolitionist Gerrit Smith from Peterboro on November 22, 1864 and on November 4, 1867. Tubman later became active in the women's suffrage movement emanating from nearby Seneca Falls.

Tubman donated her Auburn house to become a home for "aged and indigent colored people." Tubman's head injury problems grew greater, and she opted to have brain surgery while biting a bullet, without the benefit of anesthesia. Apparently she felt the pressure somewhat relieved after the surgery. She lived to a great old age, and became frail and impoverished. Ironically, she was committed to her own home as a resident. Tubman, a deeply religious Christian, left the world with these final words: "I go to prepare a place for you." In the Episcopal Church in America, Harriet Tubman is listed as a saint in the Book of Common Prayer. She died in 1913 and was buried with military honors in the Fort Hill Cemetery in Auburn. In 1944, the Liberty ship *Harriet Tubman* was named for her, and a commemorative postage stamp has been issued in her likeness. In 2003, Governor Pataki declared March 10 Harriet Tubman Day in New York State. Her old home in Auburn is today open for visitation as a historic site.

GERRIT SMITH

One of the most extraordinary characters of the region was Gerrit Smith—abolitionist, social reformer, Congressman and presidential candidate. Gerrit Smith's father was Peter Smith, who established a land business after having been a fur trader. He negotiated land from the Oneidas and laid plans for the village of Peterboro. Peter Smith was close to Chief Skenandoah, and named his son Peter Skenandoah Smith after him.

In his youth, Gerrit Smith had contact with slaves working on his father's lands before slavery was abolished in New York State in 1827, and he developed empathy for their position. Smith attended the Hamilton Oneida Academy, today known as Hamilton College, and graduated valedictorian in 1818. During his time there, he witnessed the burial of Chief Skenandoah on campus next to missionary Samuel Kirkland, and wrote about the event. Smith married Wealtha Backus, the academy president's daughter; however, she died within months of their wedding, leaving young Gerrit Smith alone. Smith's mother also died, and Gerrit's father Peter passed the family properties on to his son Gerrit. Though there were four living children in the family, there were two brothers who showed signs of some sort of mental deficiency and a sister, and so Gerrit was to run the family business on behalf of all four. Half of the property was left in trust with Daniel Cady, Smith's brother-in-law, and a relative of Elizabeth Cady Stanton. Thus, at an extremely youthful age, Gerrit Smith became an exceptionally wealthy landholder, possibly with the largest property holdings in New York at that time.

Unlike his father, who had a mind for business and accumulation of wealth, young Gerrit Smith was a philanthropist with ideas of social reform. He believed in equality among people, for women and blacks, and he was an advocate of temperance. Furthermore, Gerrit Smith had the money to make his ideas materialize.

In 1822, Smith fell in love and married Ann Carroll Fitzhugh, known as "Nancy." She bore him eight children, including stillborn twins, but only two children lived to adulthood. One of those was Elizabeth Smith Miller, who would later develop the so-called "bloomers" costume that created such as stir. She, like her father, was a proponent of abolition and a women's rights advocate.

It would be difficult to overstate Gerrit Smith's role in nineteenth-century American social reform. He was a powerful force in the abolitionist movement, and established his own church in Peterboro, based on what he called the "Religion of Reason." Smith was involved in the Syracuse Jerry Rescue and fought to test the newly passed Fugitive Slave Law by charging the arresting

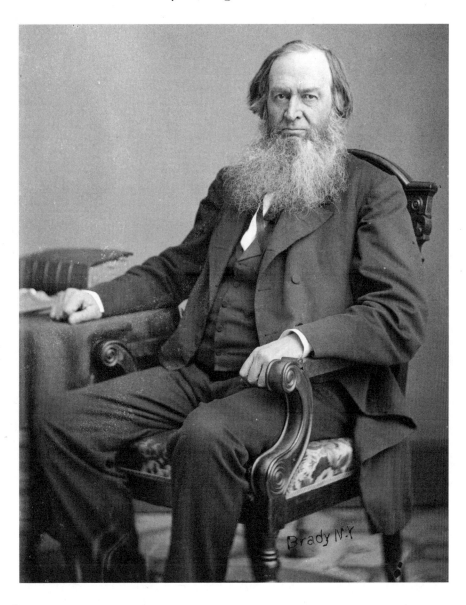

The Honorable Gerrit Smith of New York, between 1855 and 1865. Gerrit Smith used his vast resources to support abolition, women's rights and other causes. He served in Congress and was active in the Underground Railroad in Peterboro, New York. Matthew Brady, photographer. *Courtesy of the Brady-Handy Photograph Collection of the Library of Congress.*

marshal with kidnapping. He also held a yearly commemorative celebration of the event for several years thereafter. He funded John Brown, whose attack on Harpers Ferry announced the beginning of the Civil War. Gerrit Smith was a prominent figure in the Underground Railroad, often hosting fugitive slaves at his Peterboro home on their way to freedom in Canada. Smith served as a U.S. congressman, and ran for president in 1848, 1856 and 1860. Smith gave away acreage in the Adirondack Mountains to black men who were temperate but poor in an attempt to promote self-sufficiency and to allow them to qualify as voters. He also helped impoverished white men and women (although, to women he preferred to give the gift of money rather than land). In all, he is thought to have given land to perhaps two thousand black men, averaging forty acres per man.

One story about Gerrit Smith tells of Smith promising a number of girls that he would show them a great secret if they solemnly pledged their silence. Once the girls had promised, Smith lead them to an expansive room on the third floor of his home. There stood Harriet Tubman. He invited her to tell them all she had suffered during her time as a slave. Smith locked the girls in the room with her. The audience listened with amazement as Tubman told her tale. She told them: "I am doubly damned in sex and color. Yea, in class too, for I am poor and ignorant; none of you can ever touch the depth of misery where I stand to-day." At last, the light began to dim, and Harriet needed to depart toward Canada. They watched her ride into the darkening night, dressed as a Quaker woman with a veil drawn over her face.

Today the history of Peterboro is celebrated annually in the form of the Peterboro Civil War Days. For a weekend, usually the second in June, Civil War buffs from Canada and the United States converge on Peterboro and camp there on the green, reenacting Civil War skirmishes. The purpose of the Civil War Days is to honor the abolitionist and Underground Railroad history and the women's rights movement activities that emanated from the area. There are historic hay rides past the Gerrit Smith estate, now burned down save for the land office. You pass the historic cemetery and Gerrit Miller's house, a man known for his Holstein cattle, and you hear about the women's rights advocates that flourished in this small community. Peterboro is now on the National Park Service Network to Freedom National Underground Railroad Trail. Peterboro Civil War Days raise money to preserve the heritage of the area, and there are plans for a Gerrit Smith Museum.

Elizabeth Smith Miller and the Story of Her Bloomers

Though bloomers, the alternative dress adopted by some suffragists and dress reformers, bear Amelia Bloomer's name, the originator of the costume was, in fact, Elizabeth Smith Miller, daughter of abolitionist and reformer Gerrit Smith of Peterboro, New York. The history of bloomers was related by Amelia Bloomer late in her life, and though often credited with designing the fashion, she was not its originator but rather its primary publicist. Though she does not recall how Miller was inspired to create the costume, the story I was taught is that Miller adopted it after wearing the loose clothing designed to promote recuperation in a sanitarium where she had stayed for a time. She found the costume comfortable and decided to create something similar for wearing out in the greater world. Her father, Gerrit Smith, reformer and women's rights advocate, gave his hearty approval to his daughter regarding her alternative costuming.

In a sense, the time and place for bloomers was right. Women's clothing was extremely restrictive at the time, often with the use of fourteen pounds of petticoats made of stiff, heavy natural fabrics and whalebone corsets. Health problems often arose from such dress, such as physical deformity, compression of the organs and lightheadedness due to lack of breath. In addition to these issues, there was the problem that so much restrictive clothing made it impossible for women to do a variety of tasks ranging from athletics to simple work that a man would take for granted. Even the everyday jobs expected in womanhood, such as carrying a baby up the stairs while holding a candle to light the way, were difficult once many layers of long skirting were considered. Because of all of these reasons, a portion of the female population was beginning to see some manner of dress reform as necessary if women were to move forward and be viewed as equal to men in a variety of arenas.

One day in Peterboro, Elizabeth Smith Miller arrived wearing a short skirt and full-length Turkish trousers on a visit to her cousin, suffragist Elizabeth Cady Stanton. Soon, Amelia Bloomer, who published the monthly newspaper the *Lily*, adopted a similar costume. Though Miller had worn this costume for months in Washington, at home and abroad, once Bloomer's readers discovered that she was wearing the new fashion, the *Lily* was inundated with interested women, begging for the pattern. Though bloomers were often mocked and shunned by opponents of women's rights and by those who

The bloomers style of dressing was originated by Elizabeth Smith Miller, daughter of abolitionist Gerrit Smith, in Peterboro, New York. It is said to have been inspired by the comfortable clothing worn in sanitariums that gave freedom of movement to the wearer. *Bloomer Waltz*. Lithograph of Sarony & Major, New York. Published by Wm. Hall & Son, circa 1851. *Courtesy of the Library of Congress Prints and Photographs Division.*

believed they looked absurd, some women took to the new garments, savoring the freedom that the bifurcated look offered. The *Lily*'s circulation swelled as the garments became popularized and politically charged. Bloomer wore the fashion for somewhere between six to eight years. Eventually, most suffragists abandoned it as they began to feel that the issues of women's liberties were being sidelined to those of clothing reform. Also, the costume admittedly only flattered those women with youthful, sprite-like figures, and became rather unattractive on the more matronly. Stanton wore the bloomers look for a few years while lecturing and at home in Seneca Falls, but eventually was persuaded by those close to her to abandon it as well.

This piece was published in the *Liberator* on August 8, 1851:

A young lady, dressed in the Bloomer costume, who had wit as well as independence, was present at an evening party a short time since, where she attracted the attention of the gentlemen and the sneers of some of the ladies. One extremely sensitive lady, who no doubt envied the pretty appearance of the new costume, remarked to the wearer that it was a very immodest dress, and unbecoming a lady. The witty fair one replied, "If you would pull your dress up enough to cover your shoulders, it would be shorter than mine!" The modest lady, whose dress seemed in danger of falling from her person, immediately fainted, and fell into the arms of the lemonade waiter.

ELIZABETH CADY STANTON'S BIBLE

The first Woman's Rights Convention was held in Seneca Falls in 1848. Out of this arose the Declaration of Sentiments, harbinger of the birth of the women's rights movement. Stanton became known as one of the country's most ardent proponents of the cause of women's rights. Along the way, however, it became obvious to Stanton, among others, that the argument of last resort against women's rights was a religious one. Stanton, with her ferocious wit, was not one to be put off by the existing religious hierarchy. A Revising Committee of women was formed, with Stanton at its head, and the dissection of the Bible began forty-seven years after the writing of the Declaration of Sentiments. In 1898, *The Woman's Bible* was published, and among some was well received.

The method of study was as follows. It was determined that only one-tenth of the Bible contained passages that specifically related to women, and so the committee restricted themselves to those. Each committee member purchased two Bibles and cut out the relevant passages, pasting them in a blank notebook and writing beneath them.

When *The Woman's Bible* hit the market, there was quite a stir. Some people and reviewers believed it was much needed, as women had been previously excluded from biblical revisions. Others treated the work scathingly. One cleric pronounced it "the work of women and the devil." To this, Stanton handily replied, "His 'Satanic Majesty' was not invited to join the Revising Committee which consists of women alone." The work stands even today as a true shining gem. Though perhaps inaccurate and at times bizarre, one cannot read *The Woman's Bible* and fail to smile at Stanton's unfailing wit. I will quote liberally from her, as to paraphrase Stanton would hardly do her justice.

Of Genesis 1:21–25, Stanton says:

> *There is something sublime in bringing order out of chaos; light out of darkness; giving each planet its place in the solar system; oceans and lands their limits; wholly inconsistent with a petty surgical operation, to find material for the mother of the race.*

On Genesis 3:1–24 Stanton writes:

> *Then the woman fearless of death if she can gain wisdom takes of the fruit; and all this time Adam standing beside her interposes no word of objection. "her husband with her" are the words of v. 6. Had he been the*

"Ye May session of ye woman's rights convention—ye orator of ye day denouncing ye lords of creation." The Women's Rights Convention was held in Seneca Falls, New York. Elizabeth Cady Stanton and other notables were present, 1859. *Harper's Weekly. Courtesy of the Library of Congress Prints and Photographs Division.*

representative of the divinely appointed head in married life, he assuredly would have taken upon himself the burden of the discussion with the serpent, but no, he is silent in this crisis of their fate. Having had the command from God himself he interposes no word of warning or remonstrance but takes the fruit from the hand of his wife without a protest. It takes six verses to describe the "fall" of woman, but the fall of man is contemptuously dismissed in a line and a half.

Of Kings 17, Stanton tells us:

Much of the ascending and descending of the seers, of angels and prophets which astonished the ignorant was accomplished in balloons—a lost art for several centuries. No doubt that the poor widow, when she saw Elijah ascend, thought he went straight to heaven, though in all probability he landed at twilight in some retired cornfield or olive grove, at some distance from the point where his ascent took place.

Regarding the "Virgin birth" of the New Testament, Stanton says this:

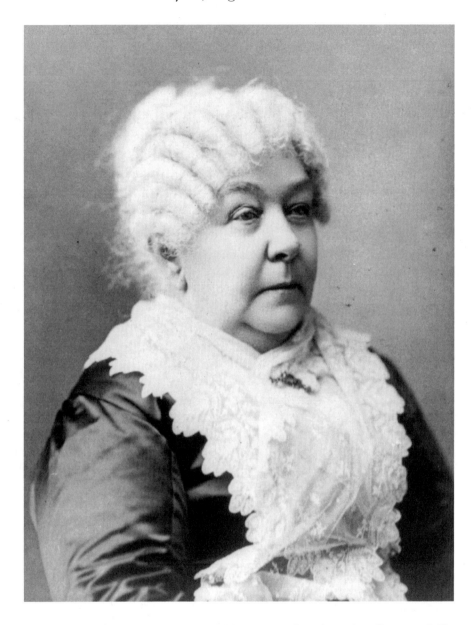

Elizabeth Cady Stanton was a controversial woman and a witty writer. She created *The Woman's Bible* with a team of female analysts. *Courtesy of Veeder—Library of Congress Prints and Photographs Division.*

I think the doctrine of the Virgin birth as something higher, sweeter, nobler than ordinary motherhood, is a slur on all natural motherhood of the world. I believe that millions of children have been as immaculately conceived, as purely born, as was the Nazarene. Why not? Out of this doctrine, and that which is akin to it, have sprung all the monasteries and nunneries of the world, which have disgraced and distorted and demoralized manhood and womanhood for a thousand years. I place beside the false, monkish, unnatural claim of the Immaculate Conception my mother, who was as holy in her motherhood as was Mary herself.

Part VI

LEPRECHAUNS, BASEBALL, THE CHOCOLATE TRAIN AND A STONE GIANT

Thomas Hastings's Heavenly Music

Thomas Hastings was born in Washington, Connecticut, the son of a doctor, but the family moved to Clinton, New York, when he was a boy. There he lived on a farm. Though he had no formal musical training, Hastings obtained work as a choir director and taught singing. He is commemorated with a bronze plaque outside the Stone Presbyterian Church on the green in Clinton, where he directed choir. His eyesight was so poor that it approached blindness, and he had been known to meet a horse on the street, bow down and politely say, "excuse me ma'am." Hastings would ride to work and tie up his horse, but walk right by it on the way home, forgetting the poor beast until morning, unable to discern its form. This did not discourage him from composing however.

Hastings composed more than one thousand hymns in his lifetime. Perhaps "Rock of Ages" is his best-known composition. He moved to New York City, where he worked another forty years as choir director after his years in Clinton. His work is extremely influential in Protestant churches even today.

Thomas Hastings's grandson was also known as Thomas Hastings. He became known for designing the New York City Library, the Frick Mansion that today houses the Frick Collection, and Arlington Cemetery's Tomb of the Unknowns.

THE CARDIFF GIANT

Perhaps the biggest hoax in New York State, weighing in at just a tad under three thousand pounds, was the famed Cardiff Giant. Its story began in 1866, when Binghamton cigar maker George Hull traveled to Iowa to visit his sister. While he was there, he met an itinerant Methodist minister, Reverend Turk, who was staying a few nights at Mr. Hull's sister's house. The Reverend Turk suggested in no uncertain terms that Mr. Hull was bound for hell, not being a reader of the Bible or a devout man. He thought Mr. Hull's interest in that new publication by Charles Darwin, *The Origin of Species*, was blatant absurdity. Furthermore, Reverend Turk interpreted the Bible in a very literal sense. He quoted Genesis, chapter 6, verse 4 as evidence that giants had walked the earth in days gone by.

While Mr. Hull thought Reverend Turk's views were preposterous, he was even more angered that his own sister defended the reverend's views. Hull stormed out of the room, determined to seek revenge on Reverend Turk and others who shared his views of literal biblical interpretation.

After arguing with the reverend, Hull concocted the plan of creating a stone giant, a fossilized piece of evidence that giants once roamed the earth, as revenge on the world's unthinking folk. Slowly, the plan began to materialize in his mind. Hull began to study a bit about fossils to understand what form his hoax would take, and two years later he was prepared to begin.

Hull traveled to a gypsum quarry in Fort Dodge, Iowa, where he once had noticed a type of easily carved stone that bore thin blue lines in it, resembling human veins. He paid some men with a barrel of beer to quarry out the immense block and shipped it to Chicago, where he had hired sculptor Edward Burghardt to carve the giant. The giant was carved to bear a remarkable resemblance to Hull himself, making the hoax even more blatant. Burghardt and his assistants, Henry Salle and Fred Mohrmann, worked secretly to include details that would create the feeling that the giant had once been living. Though the statue originally included a beard and hair, these were removed as Hull realized these parts would not have fossilized. The stonecutters included details such as toenails, and before the project was complete, a tool was formed with darning needles stuck into wood that was hammered all over the sculpture to create the illusion of pores in its skin. Still, the piece did not look much like an archaeological find. A wash of ink was placed over the statue, and then it was aged with sulfuric acid. Though remarkable at over ten feet long, truly it should have fooled no one.

The Cardiff Giant, resting under a tent in Cooperstown. *Courtesy of Tom Heitz.*

The giant was encased and shipped to Union, New York, by rail, arriving in its immense copper box. Then, it was loaded onto a wagon and it traveled north, passing by any prying eyes by night. Still, several in Tully did see an exceptionally large crate passing by. Hull was sure to tell any curious onlookers that he was hauling a large piece of machinery. At last, Hull arrived at his cousin William Newell's farm near Cardiff, not far from Syracuse. They buried the thing in the middle of the night behind the barn, and let it sit for an entire year. True revenge required patience.

As luck would have it, during the year wait, bona fide fossils were found nearby. At last, the year had elapsed, and phase two of the plan began. Newell was to hire some well diggers and have them dig where they had previously buried the giant. Newell hired some locals on October 15, 1869. It was a Friday—perhaps they were planning to exploit the weekend crowds. Newell took a divining stick and wandered the whole of his land, squandering the day with the well diggers in tow. At last, at nightfall, he determined they were to dig behind the barn. However, the light was fading and so the diggers were told to return the following day. When their work began, they had only dug three feet down when they hit what appeared to be a stone foot. Excitedly, they cleared away more, at last revealing the 2,990 pound giant. News seemed to spread instantaneously and crowds gathered to gawk. By

the end of the day, Newell had raised a tent over the exhumed giant and was charging twenty-five cents a head for admission. By the next day, the crowds were so great that Newell raised the price of admission to fifty cents, but still they came. By Monday, stage coach service from Syracuse to Newell's farm had been established. The crowds were immense. Some argued that it was an ancient fossil of a giant, such as in the Bible. Some thought it perhaps was one of the giants of Iroquois legend; others thought it was a statue of a great and ancient race. A Reverend Calthrop believed it was a statue relic left by Jesuit missionaries. Everyone looked. There were skeptics, though few, but the excitement of the find was so great that no one really cared to listen to those who proclaimed the unlikelihood of the fossilization of soft body parts such as skin.

Hull knew his days were numbered, though, and decided to sell while business looked good. A group of distinguished men from Syracuse bought a majority stake in the giant. That group included two ex-mayors of Syracuse. Soon the giant was carted off to nearby Syracuse, where the crowds were even more immense, and admission price was raised again to one dollar.

Secretly, P.T. Barnum had sent a representative to explore the possibility of purchasing the giant. It was obviously drawing crowds at a good price. P.T. Barnum offered Newell a remarkable $50,000 for the giant, but Hull told him to refuse. Not to be defeated, Barnum had an artist make a rather bad plaster of Paris copy of the giant, and installed it in New York City with the offer of a thousand-dollar reward to anyone who could prove it was less real than the other one. People began flooding into Barnum's exhibit at the expense of the real Cardiff Giant. At one point, the two were exhibited only several blocks away from each other in New York City. The owners of Hull's Cardiff Giant were outraged and ordered a court injunction against Barnum for his fake. Not to be outdone, Barnum argued, asking how one could make a hoax of a hoax. The charges were dismissed. Experts were called in from the field of paleontology, including Yale's Professor Marsh, of dinosaur fame. It was pronounced a humbug.

At last, a reporter tracked Hull down following a large money transfer from Newell to Hull, finding the Iowa quarry and the sculptors in Chicago, who admitted their secret deed. The whole thing was found to be a fraud and a great embarrassment for a large number of people and portions of the press as well. As the great P.T. Barnum would have said, "There's a sucker born every minute."

Hull went on to attempt another hoax in Colorado using clay and ape bones, but it was rather unsuccessful and transparent. At last, he left the

United States and took up residence in Europe, where he eventually died.

The Cardiff Giant was sold a few times after its fame faded. At one point, it was in the private home of Gardner Cowles, the man who eventually sold the giant to the New York State Historical Association for the Farmer's Museum in Cooperstown. But alas, not long before the purchase, Cowles's son was found chiseling away at the giant's immense genitalia. Currently, the giant is displayed at the Farmer's Museum in Cooperstown, New York. You are invited to visit the giant and sing the following song to him.

"Rock of Ages—The Cardiff Giant" is meant to be sung to the tune of Thomas Hastings's "Rock of Ages," written in 1830. The lyrics are written by Tom Heitz, Cooperstown's unofficial ambassador to the Cardiff Giant. Occasionally, Mr. Heitz brings groups of citizens to the Cardiff Giant; they gather around it and serenade the giant.

"ROCK OF AGES—THE CARDIFF GIANT"
By Tom Heitz

Cardiff Giant, flesh and bone
Ye were petrified to stone
In the ground beyond Newell's barn
Buried deep beneath the lawn
There a grave for ages gone
Till ye resurrection dawn

Men were called to dig a well
Came they bearing pick and hoe
Digging deep they struck a toe
And, 'fore long a foot, and so
Brought a Giant to the light
Man renown and man of might.

Cardiff Giant, earthly sign
Massive frame and limb supine
Curious wonders never cease
Now ye rest in naked peace
Lying sidelong on one arm
In the pit beyond Newell's barn.

Talk of town and common folk
What to make of this stone bloke?

131

Is it fossil or a fake?
A Giant drowned down in a lake?
Didst he come to grievous harm?
Laid to rest beyond Newell's barn.

Men of faith, come to pray
Singing hymns along the way
At the pit on bended knee
Citing ancient prophecy
Giants once were meant to be
Sure as Eve ate from the tree

Men of science come to learn
Fake or fossil to discern
Weigh and measure, prod and prick
Fossil true, or just a trick?
Minds divided and diverse
Babble on in Babel's curse.

Journalists did surely write
Stories of the Giant's might
Bringing thousands to the pit
Paid a price for viewing it
And 'fore long, that farmer Newell
Had the coin of every fool

In the shadows of Newell's barn
Lurked the man who bro't this harm
T'was George Hull, tobacconist
As a con, he was the best
Had his Giant carved to fool
Men of faith and men of school

Cardiff Giant, no flesh or bones
Just a clump of diatoms
Hull and Newell, hoax creators,
Soon were plagued with imitators
P.T. Barnum, a Giant made
Expressly for the circus trade.

Here's the moral of this tale
You may believe in Jonah's Whale
Or swear by Noah's ark
But beware the cunning shark
The man who bids ye pay a price
And picks your pocket in a trice

Cardiff Giant, traveled far
Pulled by horse and then by car
To carnivals and country fairs
In company with dancing bears
Seen by millions in your tent
Earned a living, paid the rent.

Cardiff Giant as a hoax
Ye've become the butt of jokes
Fame and fortune ne'er do last
Still we celebrate ye your past
Lie in peace now in ye bed
Here in Mister Clark's cow shed.

Cardiff Giant, flesh and bone
Ye were petrified to stone
In ground beyond Newell's barn
Buried deep beneath the lawn
There a grave for ages gone
'Til ye resurrection dawn.

BASEBALL, THE ALL-AMERICAN SPORT

The Baseball Hall of Fame is located in the charming rural village of Cooperstown next door to the historic Doubleday Field. Cooperstown is renowned as the birthplace of baseball, the American national pastime.

Tom Heitz, former director of the National Baseball Library located in the Baseball Hall of Fame, as well as the late Stephen J. Gould in his 1989 award-winning essay, "The Creation Myths of Cooperstown," refer to the belief that baseball was born in Cooperstown at the hand of

Civil War hero Major General Abner Doubleday in 1839 as a creation myth. In fact, they say, baseball appears to have evolved from a British type of stick ball.

The very idea that the modern game of baseball began at a discrete time and place started with famed pitcher Albert G. Spalding's search for the origin of baseball. Spalding published the annual *Spalding's Official Base Ball Guide* and hoped to define baseball as a truly American sport, locating its beginning firmly on American soil. To this end, he created a committee headed by A.G. Mills to investigate and discover the origin of baseball, but though they investigated the game, they were unable to locate a specific beginning. Then in 1907, Spalding himself sent the committee a letter written by Abner Graves telling of baseball's first game in Cooperstown. It is said that in 1839, behind the tailor's shop in Cooperstown, Abner Doubleday interrupted a game of marbles to draw out the configuration of a baseball field, and first used the name of "base ball." The committee was uncertain of the validity of this claim, but as there was not a more compelling story, it was accepted. The story gave baseball a strictly American origin and a patriotic feel, with its first game created by an American hero.

However, in 1839, Abner Doubleday was at West Point with no leave. He could not have been diagramming a baseball field in Cooperstown. It is thought that his six-year-old cousin, also named Abner, was in Cooperstown. Major General Abner Doubleday was born in Balston Spa, and grew up in Auburn, the son of a book seller. In fact, Mr. Heitz has explained to me, the only historical connection Abner Doubleday had to baseball was after the Civil War. Doubleday had been demoted after the war for what was believed to be an error on his part at Gettysburg. His recommendation to attack the rebel forces toward nightfall was overruled by Meade, his superior. The fact that he did not attack, and allowed the rebels to escape, was believed to be the fault of Doubleday and the truth was not discovered until a decade after the war had passed. Once this became known, Doubleday was considered a hero. However, in the years immediately after the war, he suffered some notoriety. After his demotion, Doubleday was placed in charge of an all-Negro regiment in Texas. Among other things, he did order some baseball supplies for his men. This is the only verifiable connection Abner Doubleday had with baseball. In fact, Doubleday was once asked what he enjoyed as a boy, and he replied that he enjoyed making maps. As far as Abner Graves the baseball informant is concerned, apparently when asked more about the event, the story changed with

the telling. Eventually, he murdered his wife and was committed to an insane asylum, where he died.

In fact, the words "base ball" could not have first been used in Cooperstown in 1839. "Base ball," spelled as two words, was a stick and ball game played in parts of Britain, though it certainly was not the modern game of baseball played in the United States today. It is referred to in print in Jane Austin's *Northanger Abbey* in the late 1700s. Also played in Britain were cricket, town ball and rounders. Rounders may have been very influential in early American baseball. Albert Spalding founded the first national league in 1876, and was adamant on proving that baseball was clearly not of British origin. Baseball as played in the United States in modern times is believed by experts to have evolved slowly into the game that is played today.

THE GREAT CHOCOLATE WRECK

One of the more savory moments in Central New York history is the famed Great Chocolate Wreck. In a periodic (but not annual) event, Hamilton celebrates its sweetest memory, which occurred on September 27, 1955. On that particular day, a New York Ontario & Western train was derailed in Hamilton at the Lebanon Street crossing. An engineer braked the train because the main switch had been thrown. However, the area had experienced heavy rains, and the train failed to stop. It busted through the coal shed instead, according to one, landing in someone's garden and spilling two car loads of Nestlé chocolate including chips, Nestlé Crunch bars and Quick! The news of the spill spread quickly throughout the community. Nearby students of Colgate University as well as locals rushed to the scene, dutifully cleaning the streets of the mess. Some scooped up handfuls of chocolate, and the more serious-minded used wheelbarrows and wagons.

That day remains dear, still, to Hamilton folk. Every so often, the event is remembered during the Great Chocolate Wreck festival, which gives locals a chance to come together, remember a bit of local history and savor chocolate in all its rich and wondrous forms. Present, too, are train displays, and in 2007, one of the events included a recreation of the famous moment using chocolate-filled train-shaped piñatas that were raced toward the coal shed using zip lines, spilling their chocolate in celebration

of history. A very large replica of the historic ill-fated train was carved into an enormous block of chocolate by a local artist who allowed bystanders to feed on the scraps. A historic sign commemorating the blessed event was erected in 2007 near the site of the train wreck. Sign or no sign, that fateful day is one Hamilton is not likely to soon forget.

THE ORIGIN OF THE SPOTTED COW

Upstate New York simply would not be Upstate without its dairy barns and its Holstein cattle. It is almost impossible to think of Upstate without visualizing its dairy land. Directly behind the old Gerrit Smith estate in Peterboro, New York, was the farm of Gerrit S. Miller. Miller imported the first Holsteins, a type of black-and-white spotted dairy cow from Holland. Miller kept meticulous records of his husbandry and bred cattle until his death in 1937. Though all the cattle imported by Miller were black and white, occasionally a brown and white one would be born from the herd. Miller imported fifty-three head of cattle between 1869 and 1879 and most U.S. Holsteins, both black and white, and brown and white, owe their ancestry to his cattle.

CAT TALES

New Yorkers love their animals. I saw one man that adored his cows so much he built a ramp into his farm house and they all lived there together, like peas in a pod, cow and man, side by side. Still, most New Yorkers prefer more mundane domestic animals such as cats. We care for our pets, we feed them, we pay exorbitant vet bills and what do we ask in return but a little loyalty, a little love. But how often do we really get it?

There was a local woman who had a cat. You know how it is—you go to the store and bring back a toy for the creature's delight. This cat had many toys that had accumulated over time. However, the woman couldn't help but notice one day that the toys seemed to be vanishing. Then one day came and the very last toy was gone. The next day she saw the cat had moved down the street to a neighbor's house and taken all its toys with it.

There was another local woman who had a cat. It was a previously owned cat—still, she loved her pet. However, this cat had one terribly embarrassing habit. It was a thief. Whenever the woman would invite a guest over, the cat would secretly rifle through the guest's purse or pockets and steal cash. This cat didn't go for string, loose coins or bits of catnip—no, it went for the green stuff, and when it had it, it would crumple it into a ball and hide it away in the apartment so that its owner might find the loot later. And find it she did, but it was usually too late to discover who the owner had been.

SMALL WONDER

Central New York is green, bright green. Perhaps it is our verdant countryside that attracts our smallest residents, a form of the little people that some folks believe reside only on the Emerald Isle. The first I heard of our native population of leprechauns was when I was giving a lecture on leprechauns for St. Patrick's Day. At the end of the lecture, a candle that had been lit suddenly extinguished itself, leaving the audience to gasp, and several to exclaim aloud, "They're here!" After that, people began to tell me of their leprechaun sightings. One young woman told me she had seen one from a train window while she was headed across Central New York. He was unmistakably a leprechaun, small in stature and dressed like a traditional Irish shoemaker fairy.

Iroquois believe in and have sighted miniature people as well. It is considered bad fortune to speak about them, so they are rarely the topic of Iroquois conversation. Still, stories do exist about these small folk. One Mohawk explained to me that they prefer the wild areas, but he had sighted one once behind the building where he lived, in the bush. While these Iroquois little people do not dress as we would expect an Irish leprechaun would, they nonetheless seem related.

One day in Utica, my husband came across a man whose ears were painted bright yellow. The man was digging beneath a tree and told my husband that buried deep beneath its roots was gold, solid gold, hidden there by leprechauns. He beckoned my husband to dig and seek his fortune. Need I say that my husband declined? Never, ever trust a leprechaun.

GEORGE "BILL" BAILEY, THE AMERICAN MUMMY

George Bailey was a poor man. He drank quite a bit, and worked on a farm and as a handyman around town, taking what work he could. Among those who were thought to have employed him was Charles A. Genung of S.J. Genung & Sons Funeral Home in Waterloo. Others say George was simply a friend of the Genungs. By all accounts, George was a penniless man, and he realized that when he died, he would be unable to afford a proper burial. This troubled him and so he went to Charles Genung and asked if anything could be done about it. An agreement was reached, verbally or otherwise (it is uncertain), but when George died, Mr. Genung would have the right to use George's body for as long as he found necessary. In exchange, he would then give George a proper burial when his body was no longer needed.

Charles Genung had created a new system of embalming that was noninvasive. He developed tools to enable embalming to be performed without mutilating the body, and the embalming appeared lasting. The embalming technique was so successful that it is the same one used today.

George died relatively young, at age forty-five, and was embalmed by Mr. Genung by a single injection. George was a tall man, six feet high, and weighed two hundred pounds. Once embalmed, he was dressed in a simple white loincloth and laid out on a marble slab in the garage behind the funeral parlor, although local legend says that George may have been posed sitting up in the funeral parlor at one time.

George became "Bill" after embalming when the tune "Bill Bailey Will You Please Come Home" gained popularity. "Bill" became the Genung Funeral Parlor's floor model for the new embalming method and morticians and funeral parlor directors traveled there from all over the world to see "Bill." The garage where "Bill" was kept, across the street from the high school, was never locked. Kids would come, sit on the porch and holler, "Hiya 'Bill!'" One girl actually tried to lift him and thought him quite light. His skin was said to be like parchment, and at one point someone stole one of his toes for a souvenir.

"Bill" Bailey was embalmed in 1899. During the time between his death and burial, he became well known to those in the community, as well as known to visitors from afar. "Bill" always received the most visitors on Halloween, when young boys were known to bring their dates to visit him.

"Bill" remained on the slab through Charles Genung's life, his son's life and during part of his grandson's life. At last, John Genung decided that

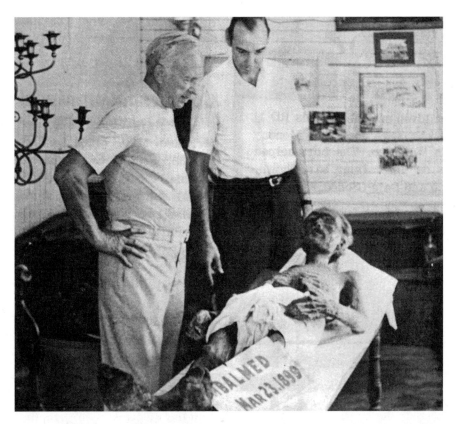

George "Bill" Bailey. Thursday, July 29, 1971 edition of the *Seneca Falls-Waterloo Reveille*. "Bill" is on the right; John Genung, of the S.J. Genung & Sons Funeral Home, is center; and Bob Sherwood, a visitor, is on the left. This photo was published the day before Bailey's burial. *Courtesy of Joseph Siccardi, owner of the* Reveille *newspaper.*

"Bill" had paid his due and that they had no further need for his services. A grand funeral was arranged. "Bill" Bailey was dressed in a tidy dark suit, unlike the coarser clothing he wore during his life or the skimpy loincloth he donned in death. A funeral was held at the S.J. Genung & Sons Funeral Home and then "Bill" Bailey was buried in the Genung family plot in an unmarked grave to deter gravediggers. Some say that it was the biggest funeral ever held in the Finger Lakes Region. Perhaps a thousand people came. Doris Wolf, who shared her experience of Bill Bailey with me, told me: "If 'Bill' could have seen all the people at his funeral, he would have just died!" At least three newspapers were present, including the local *Reveille*, the Syracuse paper and the Rochester paper. The television stations were also eager to cover the grand event. John Genung posed by "Bill" Bailey for a final photograph, and then, finally, "Bill" Bailey was laid to rest on

July 30, 1971, having worked longer and more steadily in death than he ever did in his forty-five years of life.

THE GUARDIAN ANGEL

The historic village of Barneveld lies nestled in the scenic foothills of the Adirondack Mountains. It is a community that honors its past, and you can still see one of the village's watering troughs, in the shape of a large wooden tub, down the road from the Unitarian Church. The church was established in 1803 by Francis Van der Kemp, Adam Mappa and Luther Guiteau—the first two having fled the Netherlands for political reasons, after trying to establish a government based on representation there. The church is a special place because of its history, having once been the Reformed Christian Church, constructed in 1816, bearing strong Unitarian ideas. It is also notable because of an unusual painting that once hung to the right of the pulpit. The oil painting, seventy-two inches by forty-eight inches in size, depicted a guardian angel, holding a small child by the arm, as if leading him. However, as time passed, some say the congregation grew to dislike the painting of the angel. The church had become the Unitarian Church, rather than the Reformed Christian, and belief systems had changed to some extent. The idea of the image of an angel behind the pulpit had become unappealing to some.

On July 6, 1953, the church "decided that the painting by the pulpit be removed to Unity Hall for the present." It was witnessed being taken down the road toward Unity Hall by some church members. Religious writing on the wall over the pulpit that read "That they might know thee, the only true God, and Jesus Christ whom thou have sent" was also removed between that time and the mid-sixties. Sources say the painting was stored, but not hung, upstairs in Unity Hall, a historic building that also belonged to the church. The historic plaque (apparent in the photograph on page 142 to the left of the pulpit) was also removed. The congregation originally intended to hang both the painting and the plaque upstairs in the choir loft of the chapel, but they would not fit up the stairwell. The plaque currently hangs downstairs in the rear of the sanctuary. In July, August and September of 1964, the church board sought evaluation of the paintings in Unity Hall. According to one source, an art expert that a church member knew from the Munson Williams Proctor Institute came and suggested that the painting had no monetary value, though this is difficult to imagine for a

The Unitarian Church of Barneveld, where *The Guardian Angel* once hung. *Courtesy of the author.*

painting of that size, age and workmanship, even if darkened and in need of cleaning.

In 1965, the church was being renovated, which involved more extensive projects than the 1953 repainting of the church. From there, the story blurs a bit. Some say the church held a big garage sale and sold the painting for the price of the frame. Some church members suggest that the price may have been $8. According to Ray Ramsey, the painting's current owner,

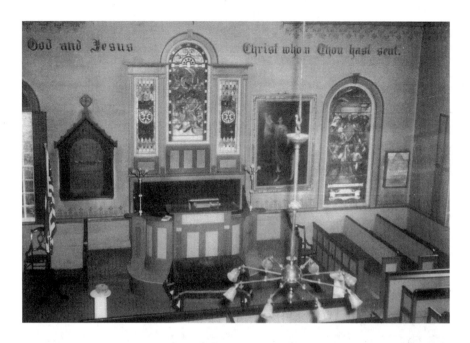

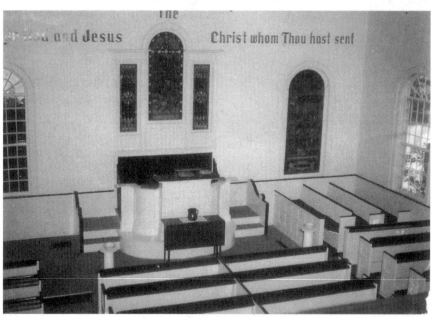

Inside the Unitarian Church in Barneveld, before (top) the redesigning of the altar and after (bottom). *Courtesy of Nadine Thomas, historian for the Unitarian Church of Barneveld.*

the painting was purchased for $1,500, the price of the frame, by Kenneth Swaizland of Toronto, Canada, in 1979. Other sources say one church member, William Bradbury, president of the Unitarian Church, brought an art collector he knew, Kenneth Swaizland, upstairs in Unity Hall to have a look at the paintings for the old frames. Kenneth Swaizland, however, stated that he purchased the painting from where it was stored in the church basement. Whatever the case, the painting was sold for the price of its frame and vanished that day, purchased by an art collector, perhaps without church approval or knowledge of the board. Bradbury (now deceased), who reputedly sold the painting, denied having done so, but the painting was gone and that was a certainty.

The painting had been donated in 1860 to the church by Mrs. Nancy Guiteau Howe. Mrs. Howe was the only daughter of church founder Dr. Luther Guiteau. In 1851, Mr. Howe was on a business trip in London with his wife, who was still grieving over the loss of their only child, Jonah. Mr. Howe purchased *The Guardian Angel* because the child, guided by an angel pointing to Heaven, seemed the very likeness of their own lost son. The painting served as a form of condolence for them. Later in life, Mrs. Howe donated the painting to the church in memory of her brother, also known as Dr. Luther Guiteau.

The painting was hung to the right of the pulpit, and there it remained for a century until it was removed during the repainting in 1953. A newspaper article still exists that tells of the donation of a "valuable oil painting from Mrs. Joseph [sic] Howe of Irvington" on behalf of her brother Dr. L. Guiteau. The article describes the painting as having been purchased in Europe and representing an angel with its right hand pointed upward, while the left hand is used to lead a small child. The painting was photographed with the interior of the church a few times over years while it hung in the Reformed Christian Church.

When Swaizland obtained the frame, he saw something in it. There appeared to be a bit of a face, the white of a wing, maybe a small person on the right. He took some cleaning fluid and attempted to clean it to discover what was beneath the dirt, but someone dissuaded him, telling him that this was art and should be cleaned by an expert. The painting was darkened from the gas lamps of the church and other exposures over the last century. Once the painting was cleaned, it was believed to be *The Guardian Angel*, perhaps by Bartolemé Esteban Murillo. However, Swaizland did not research the painting. Rather, it was sold.

The painting changed hands quickly over next few years after it had left the church in Barneveld. After Swaizland, it was sold with Van Dyke's

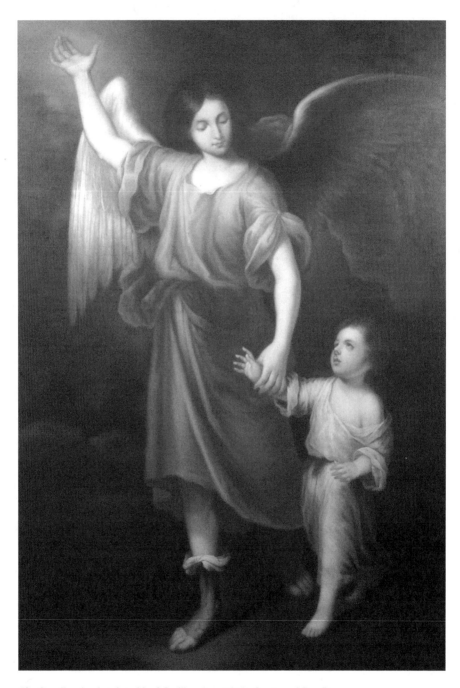

The Guardian Angel, painted by Murillo, circa 1650. *Courtesy of Ray Ramsey.*

Mourning Madonna, and the two were bought and sold together. They resided in Canada, Florida, Connecticut, New Jersey and California. *The Guardian Angel* was once traded with *The Mourning Madonna* for a yacht and as partial payment for a ranch in Carmel. At last, it became the property of Ray Ramsey in California.

In December of 1987, Ray Ramsey and his wife decided to investigate their newly purchased treasure and visited Barneveld, New York, to begin their research. Elizabeth Alger, a tall woman in her eighties, arrived and was shown a photograph of the cleaned painting. She was quite astounded and told them she used to look up at the painting as a girl when it hung in the Unitarian Church, but the painting had been so dark that it had been difficult to see the details. Elizabeth Alger helped the Ramseys gain information about *The Guardian Angel*'s past. The Ramseys then continued to research the painting, spending time in Europe hunting down the painting's elusive history. They were able to create a provenance at last.

Bartolemé Esteban Murillo was a Spanish painter who lived between 1618 and 1682. He was considered the greatest ecclesiastical painter of Spain and was born in Seville, where he painted for much of his life. Murillo painted three *Guardian Angels*. One was for the convent in Seville. One was for the Cathedral of Seville (which still hangs very high on a wall, not having been looted during the French invasion), and the third was painted for the Capuchin Monastery in Cádiz toward the end of his life. Murillo died in 1682, when he was commissioned by the Capuchin church in Cádiz. He was painting *The Marriage of St. Catherine*, one of a series of paintings (including *The Guardian Angel*) for the high altar, when he fell from the scaffolding, injuring himself greatly. Murillo died of his injuries. *The Guardian Angel* of Barneveld was painted by Murillo about 1650 for the convent in Seville. His works are considered great treasures in Spain and worldwide.

During the Napoleonic wars, the governor of Spain, Marshall Nicholas Jean de Dieu Soult, expropriated art under Napoleon. Hundreds of famous masters were divided between Marshall Soult and Napoleon. For protection, the convent in Seville sent their art to the vaults of Gibralter for safekeeping. Following the war, the art, including *The Guardian Angel*, was returned to the convent. The Spanish government desecularized the art in religious institutions, allowing their art to be sold to individuals. In 1819, Louis-Philippe purchased *The Guardian Angel* and *The Child in Swaddling Clothing* from the convent in Seville.

During that war, Europe became aware of the fine art of Spain, and it became desirable. Many works were taken from Spain to France. While

Louis-Philippe was king, he confiscated Napoleon and Marshall Soult's art collections, and the third floor of the Louvre was created to house the Spanish works. *The Guardian Angel* was displayed there.

King Louis-Philippe abdicated the throne in 1848 and fled to London, where he fought with the French government for five years, arguing that the Spanish collection belonged to him personally. At last, France allowed the collection to be restored to Louis-Philippe and it, including *The Guardian Angel*, was shipped to London. However, Louis-Philippe died shortly thereafter.

His family arranged to sell the collection at the May auction in 1853 at Christie's, which was then Christie-Manson. Hundreds of Spanish works from Louis-Philippe's collection were to be auctioned. However, Mr. Howe arrived before the auction and purchased *The Guardian Angel* from Louis-Philippe's agent and brought it back to New York. The painting never appeared at auction and has been thought to be missing for over 150 years. Mrs. Howe subsequently donated the painting to the Reformed Christian Church, now the Unitarian Church of Barneveld, and there it hung until it was removed in the 1950s. However, the story did not end there.

Ramsey offered to sell the painting to Spain for $7 million since the painting was of great historical and cultural significance to that country. However, Spain offered him property in Seville rather than money, and Ramsey refused. Spain responded by telling Ramsey that it would only pay cash if he could produce the bill of sale when the painting left Spain However, it was discovered that the bishop of Seville had the receipt. Spain sent a letter of apology, but still delayed purchasing the painting, puzzling Ramsey. He asked his agent in Spain what the delay might be. It so happened that a friend from Germany was then dealing with Spain's minister of finance. Ramsey was told Spain wouldn't purchase the painting because they could not afford it. At that time, Spain was preparing for the Olympics in Barcelona and had fought hard to become the Olympic host. Now they were running low on cash to complete the Olympic Village and the railroad. Not wanting the Olympic committee to discover that, they were drawing on a secret cache of platinum that they were sending to Switzerland. Ramsey discontinued communications with Spain, thinking it best to restart negotiations after the Olympics had ended, when Spain was in better financial condition.

Mr. Ramsey had *The Guardian Angel* by Murillo as well as *The Mourning Madonna* by Van Dyke installed in his office in his import automobile dealership. His office was accessible only by security code so few knew of the magnificent artwork within. However, one day Ramsey showed the painting

to a Japanese man who was the former ambassador to the United States from Japan, and who had purchased a Ferrari from him. The man was visibly impressed by the painting's beauty. Ramsey explained he was trying to sell the painting to Spain, and the man suggested that he wait and allow him to find a buyer in Japan. Shortly after, he did indeed find a buyer, and they were planning to come to Monterey to view the painting with intent to purchase it for $7 million. Ramsey told his partners of this.

Soon thereafter, Ramsey received a phone call telling him that he needed to come to the business. When he arrived at the dealership, he saw a police car parked out front and imagined someone had stolen a Ferrari. When he entered his office, however, he saw the two frames lying on the floor. The Murillo and the Van Dyke had been cut from their stretcher bars, rolled and taken away. His business partners were also missing. Ramsey cried out, "My paintings have been stolen! It's an inside job!" He went to FBI headquarters and told them he believed he knew who had stolen his paintings. His best guess was that it was his partners, who had disappeared simultaneously with the paintings and who knew the alarm code to gain access to the office. He knew how to find them because they were going to bring a new turbo Porsche to Italy, but since the import tax was exorbitant there, they had planned to bring the car to Germany instead, register it there and drive it to Italy. They should look for a grey Porsche with German plates.

The theft was the largest in the Monterey area's history and there were perhaps seven stories covering it. The paintings, unfortunately, were uninsured. Ramsey worked with Interpol to recover the paintings.

A year and a half later, an alert policeman in Vincenza, Italy, saw the car and remembered there was a warning about a grey Porsche. He called into the hot list and followed the Porsche to a villa in Vincenza, obtained a search warrant, and entered. The Murillo and the Van Dyke were hanging from a clothesline on either side of the fireplace suspended by clothes pins, unframed. The occupants were not thieves, but international jewel dealers who apparently traded for the Porsche and the paintings, complete with Ramsey's provenances. They had never switched plates in Italy. Though the jewel dealers were charged with receiving stolen property, they would not have been if they told who had sold it. Two years to date after they had been stolen, the paintings were at last recovered.

The theory of why the paintings were stolen is that Ramsey's partners had some shady deals with other Italian partners, who were indicted for sculpting replicas of famous racing Ferraris and selling them as genuine. Ramsey's partners had made a deal with these people, but then told them they did not

have money to pay because they had purchased *The Mourning Madonna* and *The Guardian Angel*, though the paintings, of course, belonged to Ramsey. They stole the paintings to pay the money they owed. At one point, Ramsey was summoned to Massachusetts by the district attorney and questioned, but it became obvious that he was not a part of the Ferrari scheme.

By 1995, all trials and appeals had been exhausted. Each man received a fine of twenty-five million lira, but no one served time. Still the paintings were not returned. Ramsey had contacted Reginald Bartholomew, the ambassador to Italy, but his calls were ignored. Leon Panetta, who served as congressman for Ramsey's district, became chief of staff for the Clinton administration. On Christmas Eve, Ramsey sent via FedEx all of his correspondence regarding the problem to Panetta at the White House. Bartholomew received a call from Diane Feinstein telling him to go to Verona to confirm that the paintings were there. Ambassador Bartholomew went to Verona to see the paintings and headed to Vincenza to get a release.

The following year, Ramsey's son was headed to Italy with his family. Since he would be traveling through the area, Ramsey asked his son to return with the paintings, picking them up in Milan. However, Ramsey's son called him and told him that it was not possible. Because the paintings had not been taxed entering the country, Italy was demanding a 30 percent tax on the paintings to exit. Ramsey then had to hire an attorney and, after paying costly attorney fees, two years later, the paintings were allowed to return, traveling from Milan to Frankfort to San Francisco.

When the paintings were stolen, they had been cut off the stretcher bars and rolled, then pressed flat again, causing cracks in the paintings. They needed to be relined by a restorer. The De Young Museum in San Francisco said it would do the work if allowed to display the paintings for two years. Ramsey agreed, but soon the museum wanted the paintings for ten years, so Ramsey sought another conservator. He found a skilled conservator who offered to do the job for a two-year display of the paintings. After the restorations, the paintings finally came home.

Mr. Ramsey still owns *The Mourning Madonna* and *The Guardian Angel*. For a while, he stored them, unable to deal with the paintings after having spent the last twenty years of his life on them. But now he has retired, moved to Texas and restored a historic building, where he houses a gallery on one floor. *The Guardian Angel* is being displayed publicly for the first time in many years.

Conclusion

When I first began telling stories, I told primarily European folk tales, stories we all grew up hearing. I believed that folk tales, myths and legends took centuries to evolve and, as such a young country, surely we were devoid of such things since they could develop only with the centuries passing.

I remember, too, when I first read an article about the "slow food movement," it recommended that people immerse themselves in their local culture. I wondered to myself: what local culture? What exactly is our culture? Indeed, the United States can seem like a three-thousand-mile monoculture at times, bound by mass media. I was so puzzled by the idea of immersing myself in local tradition and culture that I asked my friends at dinner what the local culture was in Central New York. Aside from the suggestion of a few festivals, we did not really come to an understanding of what that meant. It has taken time and intent to really begin to understand that concept. It is so easy to view ourselves as Americans rather than regional people that we can easily miss what is right before us.

There is something odd about this area that I have observed. We do not appear to have a distinct identity. When we think of California, we think of certain things. When we think of New York City, we think of New Yorkers as having a certain regional identity, but Central New York and the Finger Lakes Region seem to be a blank slate. No one seems to know who we are, including, perhaps, ourselves. It appears to me, we have not yet understood ourselves as unique.

Interestingly, when I think of popular European folk tales, I realize the force behind their collection and popularity was often highly political. When

the Brothers Grimm offered their folk tales from the German peasantry, they were not simply offering some old stories the country people told or memorable bedtime stories for children—they were offering Germany a new literary identity. Germany had long been dominated by the literary traditions of other lands; at last they had a literature they could claim as genuinely their own. The stories were a source of national pride and as such became popular.

During the Irish cultural revolution, when folklorists were sweeping the country, the Irish folktales and legends they collected were cherished because they displayed the national identity of a people who had been culturally suppressed by their British rulers. Again, this offered a source of pride and a distinct identity to a people in need of one.

Seeking out a region's folk tales and legends offers more than entertaining reading. It offers a piece of ourselves. These stories, each in their own way, tell us who we are and who we were. They show us our uniqueness and express the mystery of our unique heritage. They show us the richness of our past and allow us a glimpse into our collective self.

What I have offered here is only a small sampling of the stories told locally. It is only a beginning, but it is deeply a part of us, and I do believe this can be a source of regional pride. This place is somewhere like no other.

Selected Bibliography

Anataras (Alan Brant). "An Iroquoian Story of Creation." Paper from the Shako:wi Cultural Center at the Oneida Indian Nation.

Berry, A.J. *A Time of Terror: The Story of Colonel Jacob Klock's Regiment And The People They Protected 1774-1783*. Victoria: Trafford Publishing, 2005.

Bonvillain, Nancy. *Hiawatha: Founder of the Iroquois Confederacy*. New York: Chelsea House Publishers, 1992.

Brown, Josephine. "Sig Sautelle Circus." Courtesy of the Cortland County Historical Society. Newspaper and date unknown.

Bushman, Richard L. *Joseph Smith and The Beginnings of Mormonism*. Urbana: University of Illinois Press, 1984.

Clarke, Thomas Wood. *Eleazer Williams: Half-Breed Indian or King of France*. 1935. Unpublished and located at the Burke Library at Hamilton College.

Cortland Evening Standard. "The Sautelle Circus: Wonderful Intelligence Manifested by the Horses." April 29, 1903.

Cortland Evening Standard. "Sautelle's Circus: Surprised all by its Size and its Excellence" May 6, 1904.

Elm, Demus, and Harvey Antone. *The Oneida Creation Story*. Columbia: Yorkshire Publishing, 2000.

Fisher, Lillian M. *The North American Martyrs: Jesuits in the New World*. Boston: Pauline Books & Media, 2001.

Fradin, Dennis Brindell. *Hiawatha: Messenger of Peace*. New York: Margaret K. McElderry Books, 1992.

Harris, Curtis. "Cortland County Circus Star." Unknown newspaper and date.

Kelly. Blanche M. "Blessed Kateri Tekakwitha (Also known as Catherine Tegakwitha'Takwita.)" in *The Catholic Encyclopedia*, Volume XIV. Translated by Thomas, Mary and Joseph. New York: Robert Appleton Company, 1912. http://www.newadvent.org/cathen/14471a.htm.

Kimball, Spencer W. *The Book of Mormon*. Salt Lake City: The Church of Jesus Christ of Latter-day Saints, 1974.

Kunzog, John C. *Tanbark and Tinsel: A Galaxy of Glittering Gems from the Dazzling Diadem of Circus History*. Jamestown: published by the author, 1970.

The National Shrine of Blessed Kateri Tekakwitha. "The Pathway to Sainthood for Blessed Kateri Tekakwitha." April 1 2008. http://www.katerishrine.com/kateri.htm.

Noyes, P.B. "What Held the O.C. Together." Unknown newspaper, February 5, 1949.

Observer Dispatch. "Festival Celebrates 'Chocolate Wreck.'" September 27, 2007, Weekend Plus, 9.

"An Oneida Wampum String Returns Home." Oneida Indian Nation, 1999.

Pilkington, Walter, ed. *The Journal of Samuel Kirkland: 18th-century Missionary to the Iroquois, Government Agent, Father of Hamilton College*. Clinton: Hamilton College, 1980.

"The Polly Cooper Shawl." Paper obtained from the Shako:wi Cultural Center at the Oneida Indian Nation, n.d.

Rapp, Marvin A. *Canal Water and Whiskey.* Buffalo: Western New York Heritage Institute, 1992.

Robertson, Constance Noyes, ed. *Oneida Community: An Autobiography, 1851–1876.* Syracuse: Syracuse University Press, 1970.

"The Sautelle Circus: Its Exhibition in Cortland—How It Travels—The Circus Train." Newspaper unknown. May 4, 1903. File found in Cortland County Historical Society archives.

Smith, Fletcher. "Sig Sautelle, 'Babe Ruth of the Circus World' Emerges as Most Romantic Figure of Wagon Show." Newspaper and date unknown. File found in Cortland County Historical Society archives.

Stanton, Elizabeth Cady. *The Woman's Bible.* Seattle: Coalition Task Force on Women and Religion, 1898 (1990 facsimile).

"The Story of the Monster Bear, The Giant Dipper." Paper from the Shako:wi Cultural Center at the Oneida Indian Nation.

"Strange Things Which Have Happened to People I Know: L.'s Story." *American Socialist.* August 24, 1879.

Underwood, Paula. *Franklin Listens When I Speak Tellings of the friendship between Benjamin Franklin and Skenandoah, an Oneida Chief.* San Anselmo: A Tribe of Two Press, 1997.

About the Author

Melanie Zimmer lives in a century-old home in Central New York with her husband and Dalmatian. She has written for various encyclopedias and magazines and performs storytelling and puppet theater in New York State and around the country. She is a member of the League for the Advancement of New England Storytelling and the New York Folklore Society. You may visit her website at www.thepuppets.com.

YOU MIGHT ALSO ENJOY

Hauntings of the Hudson River Valley
An Investigative Journey
Vincent T. Dacquino

978.1.59629.242.0 * 128 pp. * Over 45 images * 9 x 6 * $19.99

Do spirits still stalk the Hudson River Valley? In *Hauntings of the Hudson River Valley*, Vin Dacquino works determinedly to discover the true story behind three enigmatic folk legends: Sybil Ludington, Chief Daniel Nimham and George Denny. Each was the central figure in a dramatic series of events; each became enshrined in local lore for their actions; each has had their true story obscured; and each may have left behind a spiritual residue. Follow Dacquino as he interviews local experts, explores areas where hauntings may have occurred—such as Carmel's legendary Smalley's Inn—and digs deep into historical archives to open new windows into the lives and possible afterlives of these three mysterious characters. The truth is out there, hidden in remote, tucked-away corners of the valley…are you ready to uncover it?

Visit us at
www.historypress.net